COLLIDING WORLDS

First contact in the Western Desert 1932–1984

EDITED BY PHILIP BATTY

With essays by Dick Kimber, Jeremy Long and John Kean

T0348241

museum VICTORIA

Victoria
The Place To Be

TANDANYA
NATIONAL ABORIGINAL
CULTURAL INSTITUTE

Published by Museum Victoria and
National Aboriginal Cultural Institute Tandanya 2006
© Essay text held by individual contributors
© All other text copyright Museum Victoria
© Images copyright Museum Victoria except those
obtained from essay contributors and other sources

Reprinted 2006, 2007, 2011

Museum Victoria
GPO Box 666E
Melbourne Vic 3001 Australia
+61 3 8341 7777
www.museum.vic.gov.au

Dr J Patrick Greene, Chief Executive Officer
Dr Robin Hirst, Director, Collections, Research and Exhibitions
Dr Philip Batty, Senior Curator, Indigenous Cultures Department

National Aboriginal Cultural Institute Tandanya
253 Grenfell Street
Adelaide SA 5000 Australia
+61 8 8224 3200
www.tandanya.com.au

Franchesca Cubillo
Artistic and Cultural Director

Printed by BPA Print Group
Design by Ry Drendel

National Library of Australia Cataloguing-in-Publication data:

Colliding worlds :
first contact in the Western Desert 1932–1984

Bibliography

ISBN 0 9758370 0 1

1. First contact of aboriginal peoples with Westerners -
Australia, Central. 2. Aboriginal Australians - First
contact with Europeans. I. Batty, Philip, 1952- . II.
Kimber, R. G. III. Long, Jeremy, 1932- . IV. Kean, John.
V. Museum Victoria. VI. Tandanya National Aboriginal
Cultural Institute.

994.0049915

We gratefully acknowledge that this project has been
assisted by the Australian Government through the
Australia Council, its arts funding and advisory body.

front cover (left to right)

Pitani Tjampitjinpa standing next to Donald Thomson's
expedition truck, Central Australia, 1957 (detail)

Photo identification card for Pintupi woman, Waripanda (detail)

Mitjili Napanangka carrying her son,
Mamunya Lyle Tjakamarra, 1957 (detail)

back cover (left to right)

Photo identification card for
Mick Namarari, age nine, 1932 (detail)

Mantua Nangala, age five, 1964 (detail)

Photo identification card for Johnny Warangula
Tjupurrula, age ten, 1932 (detail)

opposite

Pintupi men drinking from a lake near
Lappi Lappi rock-hole, Central Australia, 1957

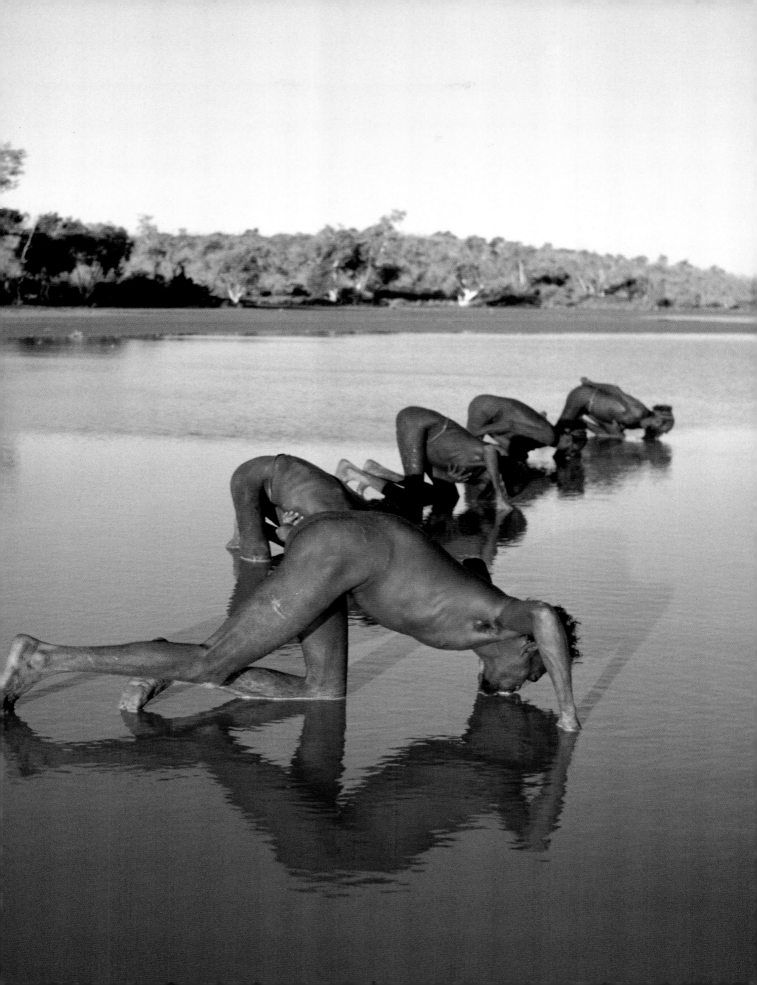

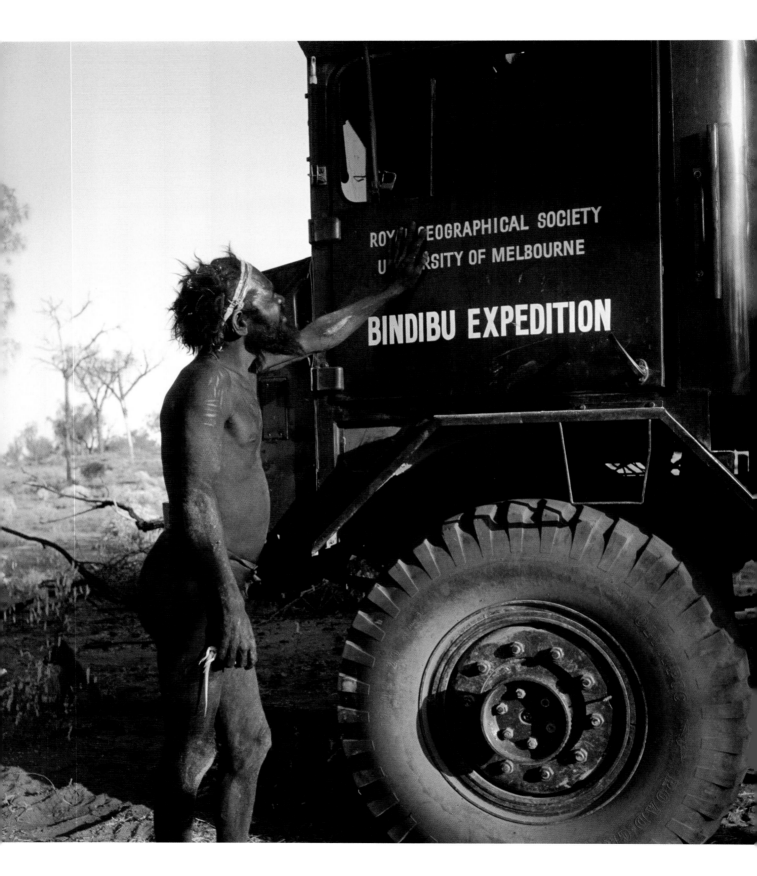

FOREWORD

Colliding Worlds: First contact in the Western Desert 1932–1984 shares with us the experiences and impact of the first encounters between the people of the Western Desert and non-Aboriginal people. These relatively recent encounters provide insight into the general relationship between indigenous and non-indigenous Australians, with implications for the identities of both.

We hear first hand accounts of the meetings and the impact on people's lives. These stories and the essays presented by historians Dick Kimber, John Kean and Jeremy Long, illuminate a pivotal moment in the history of a rapidly changing Australia.

This book accompanies an exhibition that has been developed by the National Aboriginal Cultural Institute Tandanya and Museum Victoria, first showing as part of the Adelaide Festival and then moving to Melbourne Museum before touring Australia.

Museum Victoria appreciates the support of the Australia Council in providing a grant towards this project that has made possible the publication of this book.

Dr J Patrick Greene
Chief Executive Officer
Museum Victoria

Historically, as well as today, the interface between indigenous and non-indigenous cultures has always been a site fraught with tension, anticipation and excitement. The initial point of engagement can often set the foundations for future relationships. The exhibition and this book endeavours to highlight an historic juncture of cultures and reflect the proceeding events and perspectives of the individuals involved. Provoking stories, both anthropological and Indigenous, come to life in the fabric of the exhibition and in the book.

The National Aboriginal Cultural Institute, Tandanya is honoured to present in collaboration with Museum Victoria, this wonderful exhibition *Colliding Worlds: First Contact in the Western Desert 1932–1984*.

The Institute gratefully acknowledges the on-going support and funding from the Commonwealth and South Australian Governments through the Visual Arts & Craft Strategy, Australia Council for the Arts, particularly the Aboriginal and Torres Strait Islander Arts Board, Visions Australia and Health Promotions through the Arts.

Special thanks go to the Pintupi people and the respective artists, both past and present, whose wonderful art and culture graces the walls and pages of the exhibition and book. This Indigenous community eloquently declares their rights to country, celebrates their heritage and vividly depict their history. Tandanya is truly privileged to have helped tell their story.

Franchesca Cubillo
Artistic and Cultural Director
National Aboriginal Cultural Institute, Tandanya

opposite
Pitani Tjampitjinpa
standing next to
Donald Thomson's
expedition truck,
Central Australia, 1957

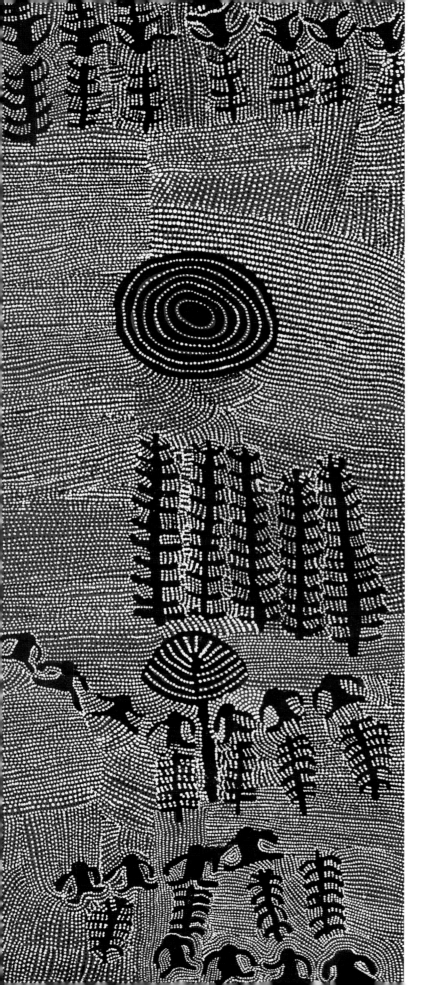

Early days living at the mission at Haasts Bluff where everyone was happy 2004
Wentja Napaltjarri 2

CONTENTS

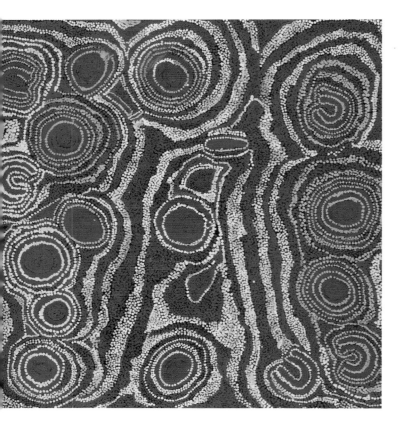

INTRODUCTION
Intercultural Debris

Philip Batty
Exhibition Curator

In 1956, a group of Aboriginal people decided to leave their homelands in the Western Desert and walk to a distant government settlement. They had never seen white people before but had heard many strange things about them. The group was led by a relative—Charley Watama—who had left the desert a few years earlier. Watama had taken it upon himself to track down his relatives and bring them back to the settlement. As he recalled: 'They were my family and they had been out there too long...they were all alone and I felt sorry for them.'

Despite the arduous nature of their 450 kilometre trek, the group numbering some thirty-four people were received with little enthusiasm when they eventually walked into Haasts Bluff settlement. Indeed, the settlement's staff seemed to regard the 'new Pintupi mob' as just another burden on their resources.[1]

Much has changed since 1956. First encounters between Aboriginals and Europeans are now subject to detailed historical analysis—whether they occurred in the Western Desert or on the shores of Botany Bay. The heated debates over what actually happened during these and other encounters now serve as important sites where the moral fundaments of Australian nationhood are contested and defined. As historian Inga Clendinnen argued in *Dancing with Strangers*, to understand contemporary Australia, one needs to understand the first interactions of Aborigines and Europeans.

The exhibition and this book presents a series of 'first contact' episodes that occurred in the Western Desert of Central Australia between 1932 and 1984. All of these encounters differed, depending on the individuals involved and the circumstances. Some were friendly affairs; some provoked misunderstandings and led to conflict, others were marked by mutual curiosity and respect, and yet others by complete indifference. Post-contact experiences also varied. Many groups enjoyed the security of settlement life and remained there. Others never adjusted and moved back and forth between their homelands and the settlements. Some individuals returned to the bush indefinitely.

The exhibition and book are presented in a way that will hopefully give viewers the opportunity to make up their own minds about such events. Certainly, it was important to avoid any form of didacticism given the ideological baggage that accounts of 'first contact' now carry. In other words, we simply present what could be described as the intercultural debris of an inevitable collision between two peoples.

The essays in this book are an indispensable part of the exhibition. Well known historian of the Centre, Dick Kimber, gives a riveting description of first contact in the Western Desert from the 19th century to the present. Jeremy Long—famed for his early patrols into the area—presents an intriguing eye-witness account of his 'first meetings'. John Kean, who worked with artists of the region, offers personal insights into the most important of these artists, Uta Uta Tjangala who, like most of his relatives, knew a life 'before trousers'.

opposite (left to right)
Tjampirrpunkungku 1996
Katarra Nampitjinpa

Satellite photograph of
Lake Mackay region,
Central Australia

NOTE
1 *Haasts Bluff native settlement daily diary*, Australian Archives (AA:CRS) Northern Territory Branch, F1.55/382

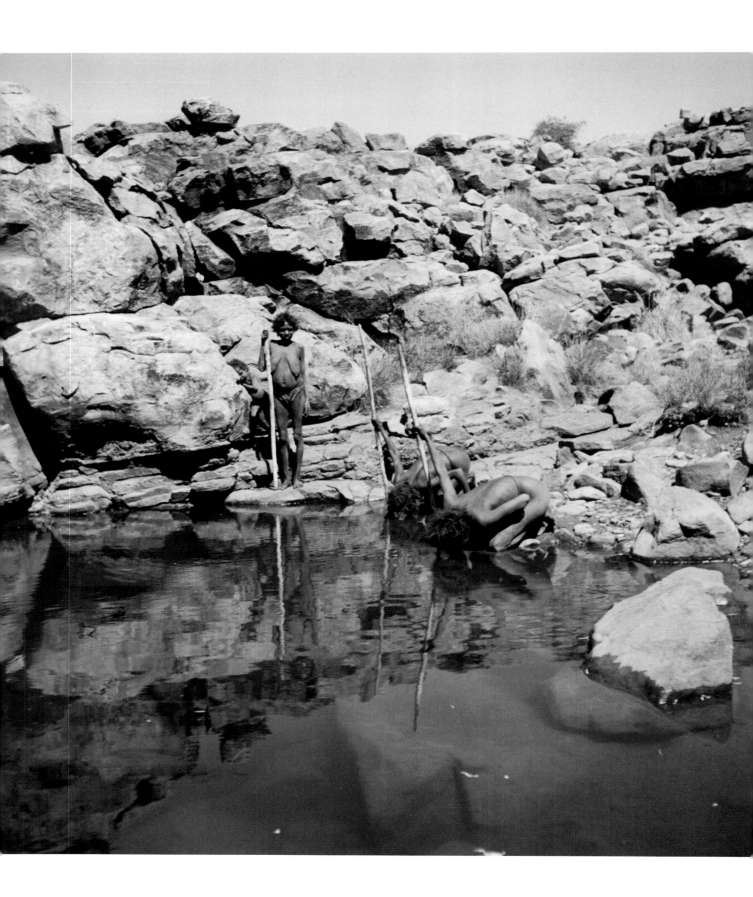

KAPI!
Contact experiences in the Western Desert 1873–1984

Dick Kimber

'We were visited by three of the natives we saw yesterday; they seem very peaceable. All I could make out from them was that they call water "carpee". I gave them a firestick, and they walked away.'[1]

The date was 4 August, 1873 and explorer W.C. Gosse, as the first European to visit Uluru (which he named Ayers Rock), had made the earliest record of the most important word in Yankantjatjarra, one of the eastern-most of the Western Desert languages.

Interestingly, Eyre had recorded the dialectal variations 'gaip-pe' and 'gab-by' for water over thirty years earlier during his travels about the Great Australian Bight, and some idea of the widespread predominance of Western Desert dialects was quickly recognised.[2] Giles, for instance, recorded '"mucka carpee", which means "no water"' in 1875 while travelling one hundred and fifty kilometres north of Fowler's Bay, South Australia[3] and Carnegie reported that 'gabbi', meaning 'water', was used a further thousand kilometres north-west over most of the vast Gibson and Great Sandy Deserts.[4]

Not all of the meetings between outsiders and the traditional owners of country were as 'peaceable' as Gosse experienced, and John Forrest's traverse of 1874 from Champion Bay in Western Australia to the Overland Telegraph Line, is illustrative of many first ever Aboriginal–European contact experiences. Beyond the regions of prior contact he met ten friendly groups, six groups who were frightened and fled, five who avoided the party, one large group who twice attacked him, and another large group who initially attacked but then became friends.[5] An example of the cautious contacts made by custodians with explorers is given in his journal entry of 29 August, 1874:

I went towards them; at first they appeared hostile, but after talking to them and making signs they began to be friendly and came down close to us…They were afraid at first when I showed them how a horse could gallop, but soon were pleased and laughed heartily. Windich shot a chockalot [Cacatua leadbeateri] and gave it to them. They were amazed at seeing the bird drop, and were very pleased when it was given to them, as they much prize the feathers of these birds.[6]

opposite

Mitjili Napanangka (standing), Mamunya Lyle Tjakamarra (child) and two unidentified women drinking from the Lappi Lappi rock-hole, Central Australia, 1957

4

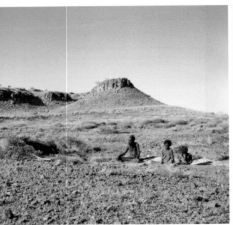 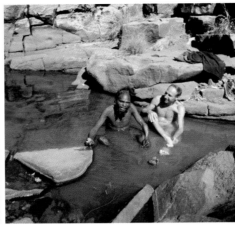

Fear and misunderstandings about the mamu 'devil' monster animals, as Western Desert peoples called horses and camels, is widely reported—and also understandable when the largest animal previously seen was a red kangaroo. In 1873 Yankantjatjarra people south of Uluru initially thought each rider and horse 'to form one animal'.[7] And as Carnegie sympathetically commented in 1897 of Pintupi women's fear of camels, 'imagine our own feelings on being, without warning, confronted by a caravan of strange prehistoric monsters'.[8]

At the same time that European explorers were beginning to learn key indigenous words, the Western Desert people began to learn English words. When south-east of Uluru in 1873, Giles was surprised to hear one man, who had evidently been as far east as the Overland Telegraph Line, call out, 'Walk, white fellow, walk'.[9] And in 1896 Carnegie noted that people one hundred and fifty kilometres south of Halls Creek knew the words 'white-fella' and 'womany', and 'had certainly heard of a rifle'.[10]

As with the words, goods travelled out along the ancient gift-exchange routes. In 1873 Giles noticed that, well west of the Overland Telegraph Line, a branch had been 'cut with an axe or tomahawk'.[11] In the same year Warburton found an 'old iron tomahawk' and a 'small bit of hoop iron sharpened at one end, like a chisel' in the Great Sandy Desert.[12] Later Carnegie recorded a tomahawk 'made from the half of a horseshoe, one point of which was ground to a pretty sharp edge' and also some glass artefacts.[13] And by 1898 Mounted Constable Cowle considered the butcher knife to be 'ubiquitous' as far west of the Overland Telegraph Line as Uluru.[14]

Between the 1870s and 1890s pastoral properties and gold-mining towns were developed about the periphery of the Western Desert. Then in 1910 the nineteen-hundred-kilometre-long Canning Stock Route was established between Billiluna and Wiluna in West Australia,[15] and several clashes occurred between traditional owners and drovers. However, it also became a travelling route along which the Mandjildjara and affiliated groups walked to re-establish themselves in the Wiluna and Halls Creek areas.[16]

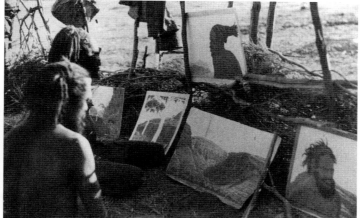
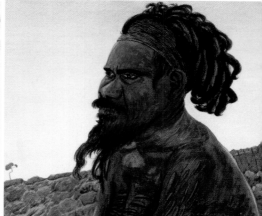

Permanent changes tended to come in times of drought, when the desert dwellers sought long-term sanctuary in the better-watered lands. The men found that there were interesting jobs as stockmen and trackers, the women realised that there were some benefits in being shepherds or domestic helps, and many of them married into and stayed permanently in their neighbours' countries. As Carnegie indicated of the situation in and about Halls Creek in the 1890s, though, while numbers became employed, many became mendicants.[17]

A worldwide tragedy occurred in 1919 when Spanish influenza was spread by troops returning home from World War I. The influenza reached Alice Springs and Hermannsburg, then was carried west, so that 'many blacks died' near Alalya rock-hole, an eastern Pintupi water.[18]

Several events now occurred which led to ever-increasing attention being paid to the Western Desert peoples. In 1927–28 famished Warlpiri speared some cattle and murdered an old man called Fred Brooks on Coniston Station. Patrols led by Mounted Constable Murray admitted to shooting thirty-one people, though most unofficial accounts indicate that scores more were shot. It was the last major massacre of indigenous people in Australian history.

At the time of the Coniston Massacre, Michael Terry was pioneering the use of trucks in the deserts.[19] Many Western Desert peoples were terrified when they saw these charging metal monsters with huge headlight 'eyes'. The late Jack Ross Tjakamarra (ca. 1910–2004) told me of his fear when he saw the tracks of a truck near Mt Theo. They must have been made by enormously heavy 'devil' snakes, he thought. And yet many of the people overcame their fear and, as *Untold Miles* reveals, helped push a 'silly feller' truck out of a bog near the Tomkinson Range.[20]

More dramatic contact was witnessed by members of the University of Adelaide Anthropological Expedition at Hermannsburg. In August 1929 dying people began to arrive at the mission. Norman Tindale recorded that the '[older] Aborigines, reduced to skin and bone, staggered in, carrying

left to right

Pintupi family camped in Central Australia, 1957

A Pintupi man taking a bath with Bill Hosmer, a member of the 1957 Donald Thomson expedition to Central Australia

Patuta Arthur Tjapanangka, Lake Mackay region, Central Australia, 1957

Unidentified figures in the Kintore Ranges region, Central Australia, 1957

Men recently arrived at Hermannsburg, viewing Rex Battarbee's watercolour paintings, circa 1945

Teltelkna 1945
Rex Battarbee

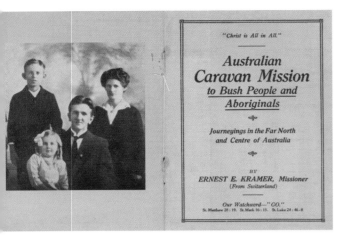
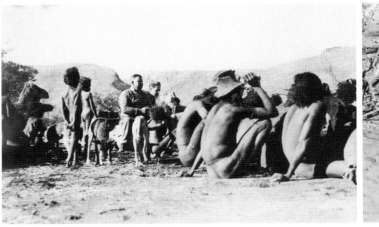

children on their backs'. They were suffering from 'abject starvation with the appearance of a form of scurvy', so much so that some children died shortly after arrival, or were so malnourished that they were crippled for life. 'An estimated two hundred people were involved', and treatment by medical doctors who were present, 'with vitamin treatment and orange juice' saved many lives.[21]

The next year saw the Mackay Aerial Expedition using an airstrip constructed at the Ehrenberg Range, and the calamitous 'Lasseter' gold prospecting expedition also using the Ehrenberg airstrip. The late Ray Inkamala Tjampitjinpa and Johnny Warangula Tjupurrula told of the Pintupi people's initial fear at the arrival of the giant 'eaglehawk' aeroplanes. They had warily approached once they saw the giant birds disgorge people who were still able to walk around, and had enjoyed the sweetness of boiled lollies. After the aeroplanes and support groups had departed, many who had found the contact exciting followed camel and truck tracks to Mount Liebig and Putardi Spring.

In contrast to these happy experiences, Walmala revenge parties began murderous activities in Pintupi country and that of their neighbours in the 1930s, with 'payback' avenging parties in turn tracking down those who had committed the murders. The stealing of a woman from one group appears to have started it all, and it is clear that fear of the Walmala contributed to some of the migration east by survivors. Mick Wagu also told of six murders, including three carried out because of transgressions during ceremonies, and one because the man was always chasing oher men's wives.[22]

These and other events such as The Granites gold-rush led to a flurry of scientific activity. After work at Cockatoo Creek, the Adelaide University team set up camp at Mount Liebig, while various cameleers set out to contact Warlpiri, Yumu, Luritja and Pintupi people. Patrol officer T.G.H. Strehlow located Warlpiri to the north, finding that, as Michael Terry independently observed in the same year, they 'were living on sandhill yams'.[23]

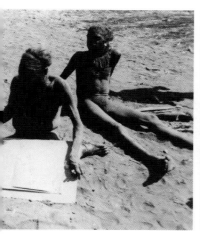 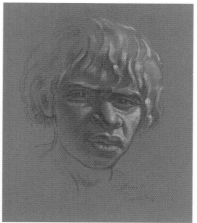 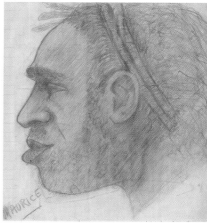

left to right

Man drawing on paper,
Mt Liebig, 1932

Crayon drawing by
Mintun Mintun,
Mt Liebig, 1932

Luritji boy 1934
Arthur Murch

Drawing by H.K. Fry
of Wanatjakurrpa or
'Maurice' at Mt Liebig,
Central Australia, 1932

An Aboriginal assistant to the expedition located a group of Pintupi and encouraged them to come in, thus allowing the first scientific studies of these people. Much as, when reading of the making of plaster face-masks, taking of blood and hair samples, and other intrusive acts, one tends to react against the insensitivity of the scientists. Old Bert Nyananya Tjakamarra and numbers of younger people who were involved told me that they were not troubled by it. The Aboriginal assistants to the expedition had enabled them to understand that nothing evil was intended, the scientists had been friendly and reciprocated with food and other gifts, and they laughed at the memory of this strange 'whitefellow business'.

Knowledge of the considerable number of Western Desert people who had been attracted to Mount Liebig encouraged evangelical work. From 1930–35 several major Hermannsburg Mission contact patrols were made into the lands of the Warlpiri, Pintupi and Pitjantjatjarra. One of the consequences was that, along with the gospel that they heard for the first time, many were also led to understand that unlimited food was to be had at Hermannsburg.[24] This had not been intended, but as Pintupi man Benny Tjapaltjarri told me, after 'drinking' a tin of sweet jam, he walked into Hermannsburg, tasted other interesting new foods, then carried half a bag of flour out west on his head and, by making damper bread, encouraged other kinfolk to travel to the mission.

A period of mission expansion and consolidation, which had Western Desert peoples as their eventual main residents, followed all about the deserts of the Northern Territory, South Australia and West Australia, mostly between the 1930s and 50s. These included Ernabella and Ooldea in South Australia, Haasts Bluff, Areyonga, Yuendumu and Papunya in the Northern Territory, and Balgo, Jigalong and Warburton in West Australia. These were created not only to spread the Christian message, but also to act as buffer ration depots, preventing the unscrupulous exploitation of people by such as rogue doggers and prospectors, and to prevent the disintegration of those groups who remained in their heart country.[25]

Expedition Leaves to Study World's Last Prehistoric Race

SCIENTISTS' PLANS

S.A. Party and Aborigines

MUCH TO DO

To help science complete the knowledge of what is regarded as the only prehistoric race left on the face of the earth—the Australian aborigines—one of the most important scientific expeditions, and the best equipped, which has ever gone to the heart of Australia left today.

The expedition consists of 12 scientists. It has been organised by the board of anthropological research of the University of Adelaide.

The scientists will spend a fortnight in intensive study of aborigines at Mount Liebig. Five similar expeditions have visited other regions in previous years.

Streamers were let loose as the northbound train pulled out from the Adelaide Railway Station. All the scientists were looking forward to the camp in the Central Australian wilds.

"It's a great holiday, as well as a job of wonderful interest and value," said Dr. Kenneth Fry, resplendent in riding boots and khaki breeches. He will leave behind him for a while his University lectures on drugs to study the mentality of the blacks.

PINK BERET

And all the rest agreed with him, from Prof. J. B. Cleland, leader of the expedition downward.

To show that he was not awed by the presence of three university professors—Prof. T. Harvey Johnston, veteran of Antarctic expeditions, to whom this trip probably seems but an afternoon's stroll; Prof. C. S. Hicks, and Prof. Cleland—Mr. N. B. Tindale, the ethnologist of the Museum, sported a bright pink beret.

Mr. E. O. Stocker, who left off directing a calcimine company in Sydney to give the party the benefit of his expert skill at his hobby of cinematography, took 10,000 ft. of film with him.

In addition to taking pictures of the fast-diminishing aboriginal race, which will be of permanent historic value, he will make travelogue films for a Sydney company.

On last year's expedition to Cockatoo Creek, Central Australia, Mr. Stocker took 3,000 ft. of pictures, which have been shown in Adelaide.

Temporarily transferring his energy from motor body building to a scientific sideline of his—meteorology—Mr. E. W. Holden, chairman of directors of Holden's-General Motors, took along a complete weather-recording plant, with which he will observe in detail climatic conditions that prevail during physiological tests of the blacks by other members of the party. His observations will be co-related with their results.

A phonograph recording instrument will help Mr. H. M. Hale, the director of the Museum, and Dr. T. D. Campbell in their study of the musical capabilities of the natives.

EXPERT INTERPRETER

The blacks' attitude to life will be the main concern of Dr. Fry, the psychologist of the party. In previous expeditions he has devoted himself to measuring the senses of the aborigines—sight, hearing, and smell—and setting them small problems, such as following out mazes.

But this year he hopes to gain a greater insight into their mental outlook through having the services of a more expert and experienced interpreter than has previously been available—Mr. T. G. H. Strehlow, a research student of the University, who has been in Central Australia since May studying native languages.

Mr. Strehlow will make the thirteenth member of the expedition. Three other young University men in the party are Mr. J. H. Gray, H. Moore, and E. Eldridge.

A motor car and lorry will take the scientists over the 200 miles from Alice Springs north-westward to Mount Liebig. Heavy equipment has been sent on ahead.

COST £500 EACH

The expeditions cost about £500 each, and the expense is largely borne by a fund donated by the Rockefeller Foundation and administered by the Australian National Research Council.

Prof. Cleland is chairman of the University Anthropological Board, under whose auspices the expeditions are sent out, and acts as leader. "But the credit of organising the trips belongs to Dr. Campbell, our manager," said Prof. Cleland.

Dr. R. H. Pulleine, Prof. H. J. Wilkinson, and Dr. Rex Matters were on the platform to bid the travellers an envious farewell. They went last year, and would like to have gone again, but could not. Dr. Pulleine and Prof. Wilkinson will leave for Sydney next week to attend a congress of the Association for the Advancement of Science.

"But I'm going next year," said the grey-haired Dr. Pulleine.

(On Page 8 Prof. Cleland tells what the expedition will do, and the lessons the blacks may teach us.)

9

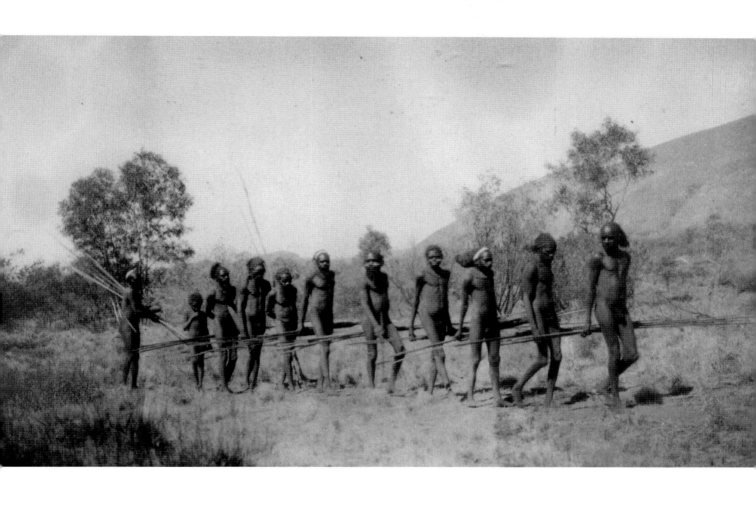

left to right

A group of Pintupi
walking in from the west to
meet the University of Adelaide
Expedition at Mt Liebig,
Central Australia, 1932

opposite

Extract from a story by
Max Lampshed about the
scientific expedition to
Mt Liebig and published in the
Adelaide newspaper
The News, 1932

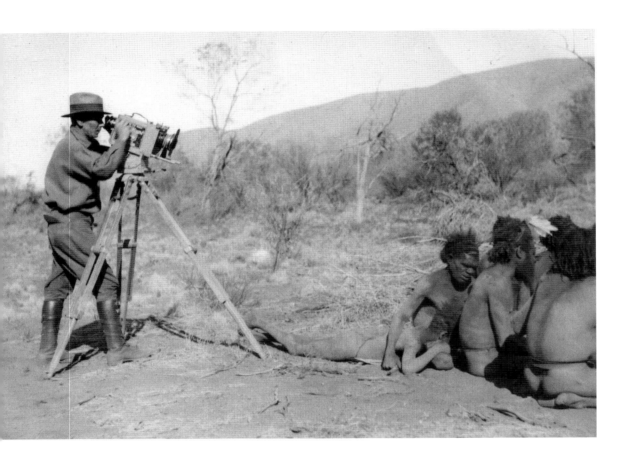

Cameraman E.O. Stocker
takes film footage at Mt Liebig,
Central Australia, 1932

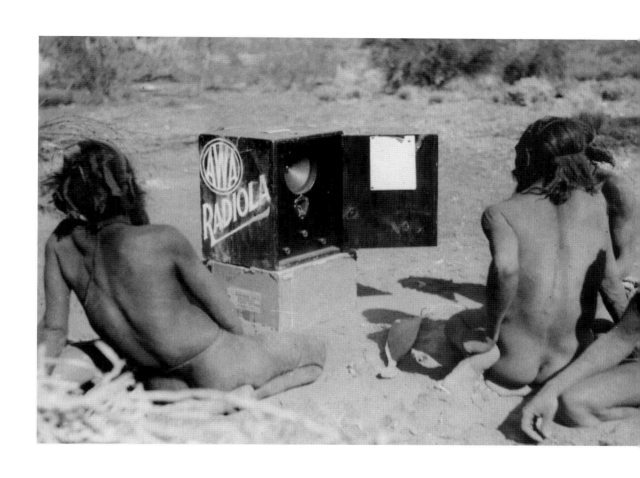

Men listening to a shortwave
wireless at Mt Liebig,
Central Australia, 1932

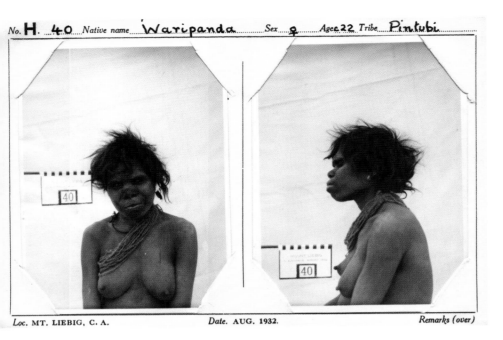

No. **H. 40** Native name *Waripanda* Sex ♀ Age **22** Tribe *Pintubi*

Loc. MT. LIEBIG, C.A. Date. AUG. 1932. Remarks (over)

No. **40** Native name *Waripanda* 　 Tribe *Pintubi*

Sex ♀ 　 Age *c.22* Secret name _____ White name _____

Where born _____ Subclass *Pangarta (Aranda)* Totem _____

Father's name _____ Tribe _____ Where born _____

　 Subclass _____ Totem _____ Where died _____

Mother's name _____ Tribe _____ Where born _____

　 Subclass _____ Totem _____ Where died _____

Brothers _____

Sisters _____

Husband's or Wife's name *Yarukulu* *not in camp* Tribe _____

Where born _____ Subclass _____ Totem _____

Male Children _____ Subclass _____ Totem _____

Female Children ♀ ¹ 　 Subclass *Ngala (Aranda)* Totem _____

Photogr. **F. S.** nos **89-90.** Loc. *Mt. Liebig, C.A.* Date *Aug. 1932.* Remarks (over)

top

Photo identification card for Pintupi woman, Waripanda

bottom

Genealogical information card for Waripanda

opposite top

Plaster life-cast of Waripanda

opposite bottom (left to right)

Carrying dish collected from Waripanda

Pubic apron collected from Waripanda

Fibre rope collected from Waripanda

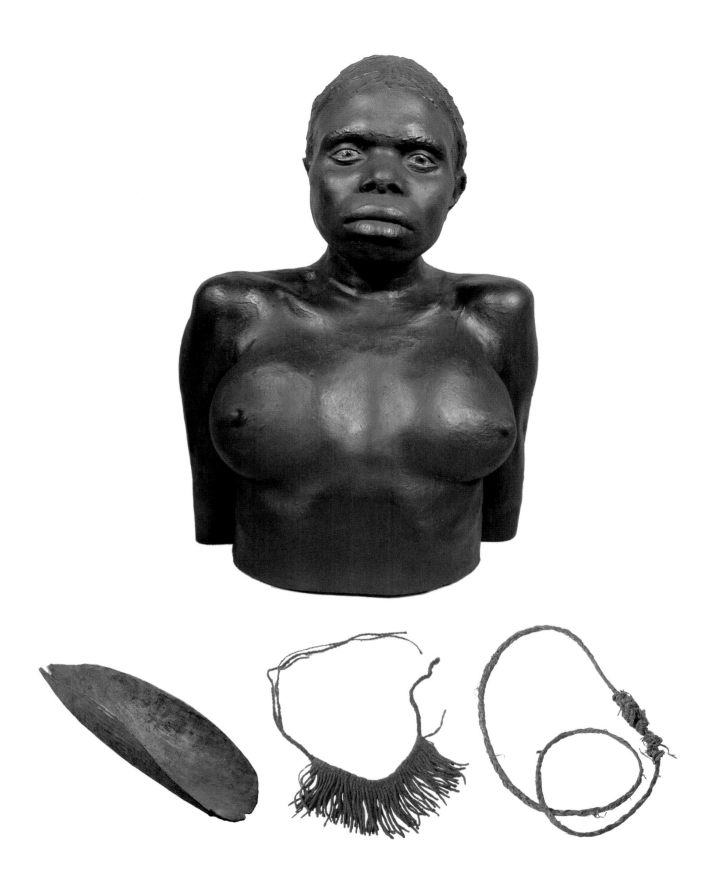

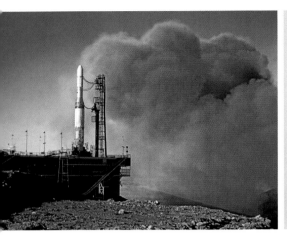
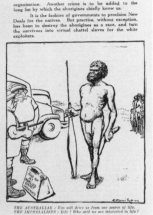

left to right

Static firing of a Blue Streak rocket at Woomera. In the only mishap, a Blue Streak broke up, scattering debris across the south-east of the Central Aboriginal Reserve. No one was injured as a result

Reproduction of a cartoon from the booklet, *Rocket Range Threatens Australia*, published by the Australian Communist Party in 1947

Probably the key figure recalled by all old Pintupi who met him in the 1930s was Kungki. His true name was Sam Hazlett, a legendary prospector, and he was remembered by a large number of people because he prospected more widely than anyone else over Ngaanyatjarra, Pitjantjatjarra and Pintupi country. What they most remembered, though, was his reputation for eating human flesh. The late Shorty Bruno Tjangala, Uta Uta Tjangala and many other Pintupi recalled him in animated discussions with me in the 1970s. Michael Terry provides the explanation of the belief in a note of 1933:

> [Some] months previously another party of camelmen had sat down near Sladen Waters. Bush blacks having come up, one of them was offered a lump of fat bacon. He refused and at once walked away to his brethren some distance from camp—to tell the awful news.
>
> 'White feller eat'em lubra fat.' The wretch had mistaken bacon for human flesh, had jumped to the conclusion that his hosts were cannibals. To avenge this insult they gathered spears, attacked the camp, lost one dead and another wounded.[26]

He remains in Pintupi folklore, though, as the fearful cannibal, Kungki.

Many Western Desert people who were in contact with white Australians heard of World War II, and the arrival of trains, convoys of trucks and 'army men' in Alice Springs. The news attracted Pintupi men Charlie Wutuma Tjungurrayi and Nosepeg Tjupurrula into the Alice, where they were hugely impressed by the Regimental Sergeant Major, whose immense barking voice was instantly obeyed by hundreds of marching men. They thought him akin to the great ritual leaders, exerting life-and-death authority over initiates. The appeal of an army uniform was short-lived, for as Nosepeg put it, there was 'March, march, too much altogether!' They travelled by truck to Darwin, were astounded by the vastness of the sea and in awe of the size of the crocodiles; ran for their lives when bombs started falling, and also travelled to Wyndham. It opened their eyes to a 'different, different' world to the deserts.

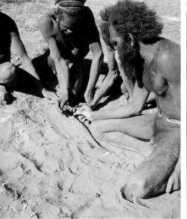 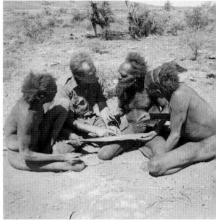

Immediately after the war camels, donkeys and horses, which had been becoming less and less significant for transport after the Great Depression, often became the property of Western Desert peoples. They enabled easy travel into homeland country so that renewal of associations with important sites, hunting and gathering, and activities such as dogging to acquire dingo scalps for which a bounty was paid, became quite common.

At the same time the Maralinga atom-bomb testing site, and the Woomera rocket range were developed in South Australia. Their impact has been considered in detail in many enquiries. W. Grayden's *Adam and Atoms* (1957), with focus on the Warburton Mission region of Western Australia, captures the passionate concerns that were held in the decade after the tests commenced.

A major feature of the development associated with the rocket tests—for the protection of any groups who might be in the flight path, as well as for reasons of recovery—was a vast grid of graded roads through the Western Deserts.[27] Coinciding with these developments were Jeremy Long's patrols to make contact with the remaining Pintupi and other groups. Douglas Lockwood's *The Lizard Eaters* (1964) gives a popular account of one such patrol, while Donald Thomson's *Bindibu Country* (1975) gives an anthropologist's popular scientific account of more detailed observations. One striking image that remains in my own mind is Nosepeg's account of people being terrified when, after travelling from the far west for hundreds of kilometres into the Mount Liebig country, they saw a windmill in the distance, partly obscured by trees. It was a still day, and the blades were not turning, so that it appeared to be a tall conical head-dress commonly used in men's ceremonies. This must be a land of giants, they thought, until reassured by Nosepeg about its nature and purpose.

Throughout the time following World War II the Federal Government's policy of assimilation had been questioned by an ever-increasing number of Australians. By the early 1970s it was clear that the policy was about to change. At the same time schoolteacher Geoff Bardon had encouraged the senior men of Papunya to transpose their traditional sand, rock-shelter and body art onto art-

left to right

Pintupi men examining a spearthrower with carvings of various waterhole sites

A newspaper pictorial supplement about Donald Thomson's 1957 expedition to Central Australia published in *The Age*, 13 and 20 November, 1957

Donald Thomson discusses iconographic decorations on a spearthrower with a group of Pintupi men

board and canvas. They were clearly painting their homelands of the mind, and it was also the decade when Aboriginal ownership of motor vehicles meant the end of the old camel and horse era. As soon as the Federal Government changed its policy from assimilation to self-determination in 1972, the Pintupi self-determined to move west, back towards their own country. As Nosepeg Tjupurula stated when asked by a television director why a group of people wanted to move far to the west, 'Why? Because it is our country.'

As the Pintupi were planning their move to the Ehrenberg Range in 1976–77, young Mandjildjara people were assisting W.J. Peasley and friends in a search for an old Mandjildjara couple. When they were found they were thought to be, as the title of the book about them indicates, *The Last of the Nomads*.[28]

Even as the book was selling in the bookshops the continuum of Pintupi life was good for Pinta Pinta Tjapananga and his family. It was 'the day before the rodeo was to be held in Alice Springs' in 1984, as the three bush workers who were erecting Winbarku (Mount Webb, West Australia) hand-pump remember the time. After the workers departed for Alice Springs, as Pinta Pinta told me, he and his family set up camp for the night, for Winbarku was Pinta Pinta's home country. They used the hand-pump to fill billies with good Winbarku water, sat by the fire and ate their evening meal, and relaxed while one of Pinta Pinta's sons played a country and western tape on his portable tape-player.

'Kapi pu:u!'

The call came out of the darkness. Kapi water, pu:u an attenton call. Two Tjapaltjarri brothers, whose family had last seen their kinfolk in 1962, had come in search of kapi. For several years now they had seen from afar the smoke of fires, sometimes to the distant north, east or west, but mostly south along the old Len Beadell road to Kiwirrkura. Their larger family group had stayed two days 'foot-walk' back in the sandhill country. Now they needed water.

And so 'the last of the nomads' came to Winbarku hand-pump in 1984. And a year later 'the last of the nomads' were found again, but this time they were 'the Spinifex People' far to the south.

Perhaps all people on earth need a sense of the continuing existence of 'nomads', for all of our ancestors were once so. They remind us of who we are.

NOTES

1 Gosse, 1973: 11
2 Eyre, 1964, Vol. 1: 215–224, Vol. 11: 296.
3 Giles, 1999: 25.
4 Carnegie, 1973: 297, 374, 393.
5 Forrest, 1969: 158–258.
6 Forrest, 1969: 241.
7 Giles, Vol.1, 1979:177.
8 Carnegie, 1973: 393.
9 Giles, 1979, Vol.1: 176.
10 Carnegie, 1973: 284, 369.

11 Giles, Vol.1, 1979: 158.
12 Warburton, 1981: 199, 220.
13 Carnegie, 1973: 258.
14 Mulvaney, Petch and Morphy, eds, 2000: 104
15 Smith, 1966.
16 Tonkinson, 1974.
17 Carnegie, 1973: 329, 353.
18 Smith, 2005: 50.
19 Terry, n.d.
20 Terry, n.d., plate facing p123.

21 Tindale, 1974: 69.
22 Davis, 1994: 72–73.
23 Strehlow, 1970: 136; Terry, 1937: 84.
24 Albrecht, 1977: 48–54; Henson 1992: 32–62.
25 e.g., see Grayden, 1957; Henson, 1992; Hilliard, 1968; Tonkinson, 1974.
26 Terry, 1937: 186–187.
27 Beadell, 1989.
28 Peasley, 1983.

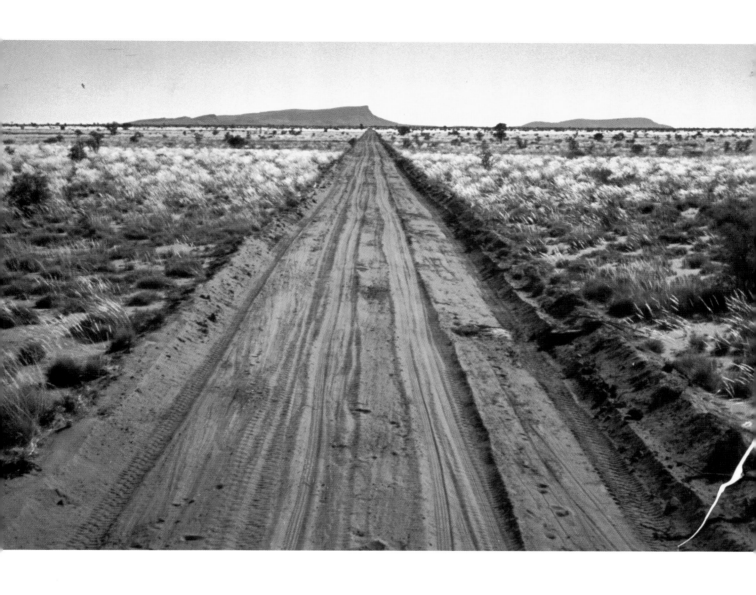

The Gunbarrel Highway
across Central Australia was
constructed by Len Beadell in
the early 1960s. This road still
serves as the main thoroughfare
for most Western Desert
Aboriginal communities

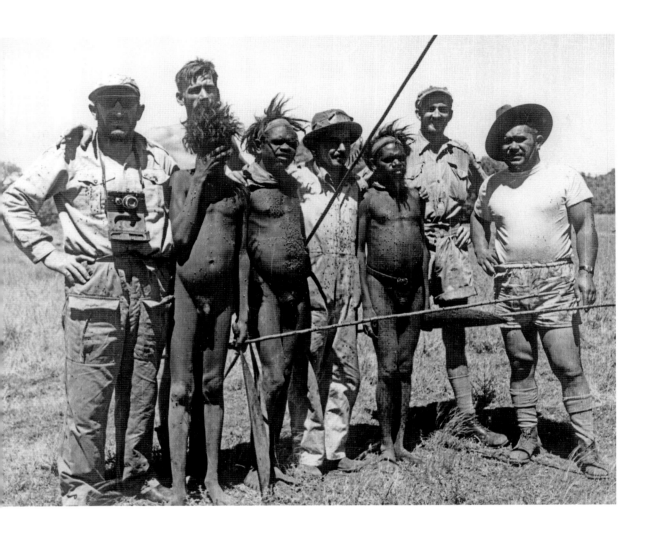

A reconnaissance party
of the Weapons Research
Establishment and Pintupi men
in the southern Central
Aboriginal Reserve, 1950

19

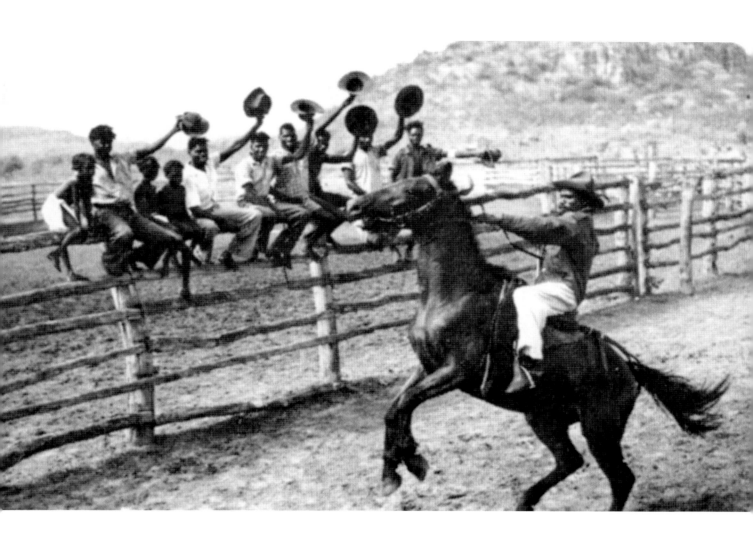

Stockmen near Haasts Bluff,
Central Australia,
circa 1955

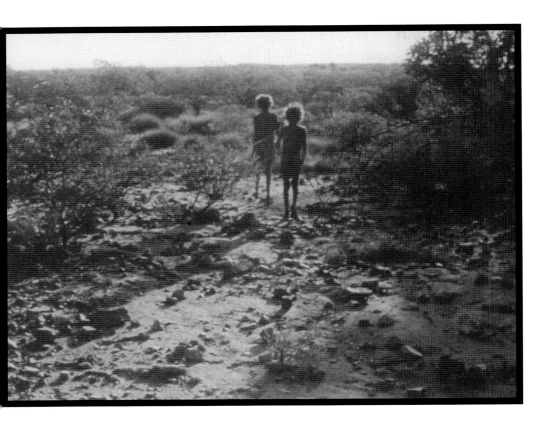

Stills taken from the film *Pintupi*, an ABC documentary made by Frank Few in 1964 while on patrol in the Western Desert with Jeremy Long. The sequence of stills depicts the patrol meeting members of Anatjarri Tjampitjinpa's family, some of whom had never met Europeans before.

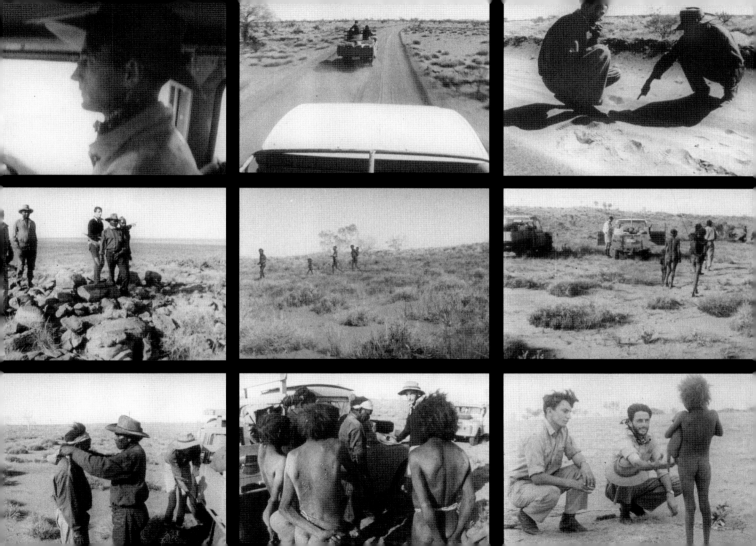

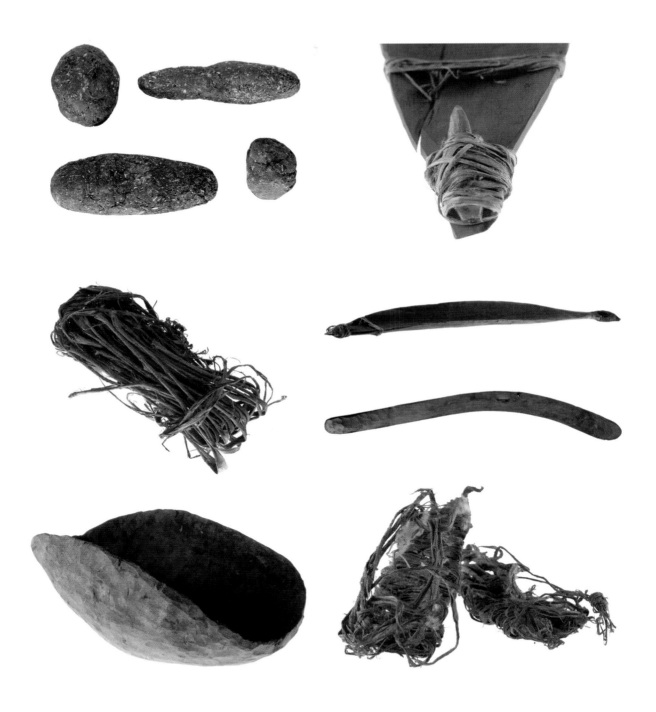

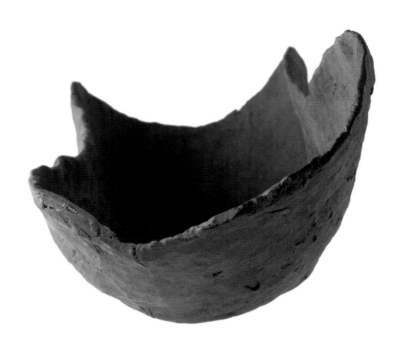

above

Carrying dish

opposite
(clockwise from top left)

Spinifex resin

Woomera (detail)

Woomera

Boomerang

Bark twine footwear

Carrying dish

Bark twine bundle

Artefacts collected by
Donald Thomson during
his 1957 expedition to
Central Australia.
Although deceptively
simple in design, the
multi-purpose artefacts
provided their Aboriginal
makers with the essential
tools needed to survive

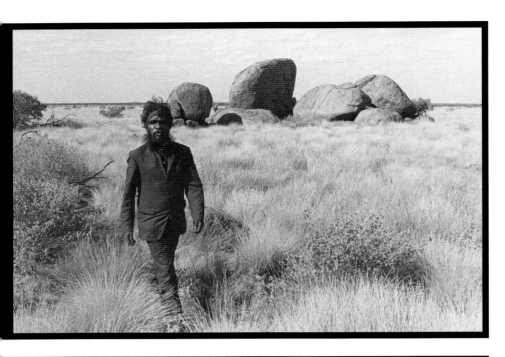

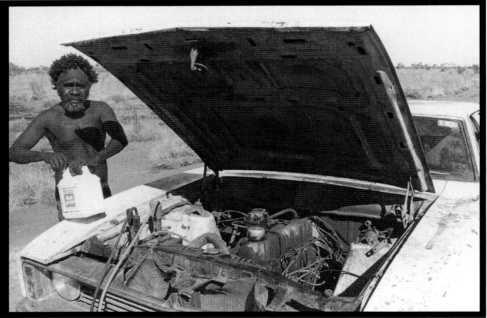

Photographs taken by Jon Rhodes between 1974 and 1996
in various Aboriginal communities and outstations in the Western Desert

top

John Tjakamarra near Walungurru,
Kintore Range 1974

bottom

Fred Tjungurrayi Ward, Kiwirrkura 1990

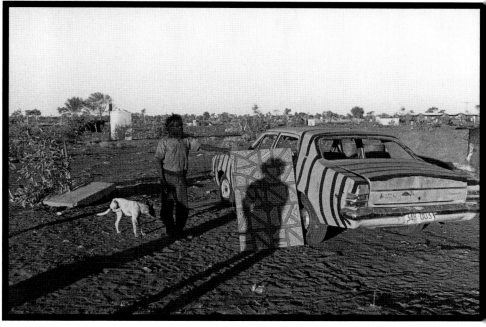

top
Elwyn Tjampitjimpa Yapa,
Kiwirrkura 1990

bottom
Charlie Tjakamarra Ward,
Kiwirrkura 1990

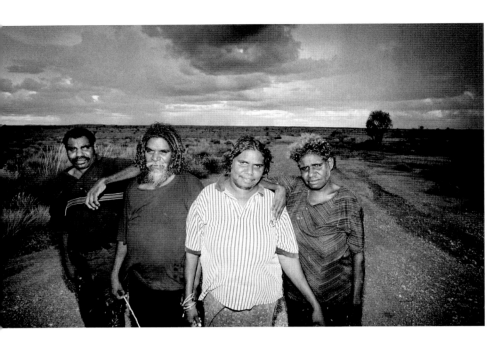

We find the lost tribe

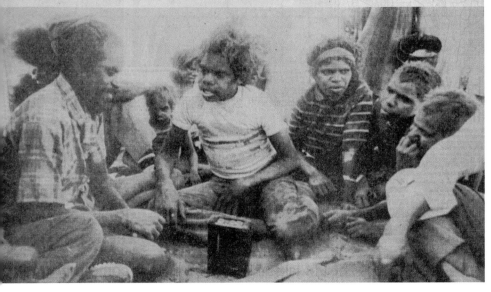

top

Photograph taken in 2004, of Thomas, Warlimpirrnga, Yalti and Yukulti who walked out of the bush in 1984

bottom

Front page of the Melbourne newspaper *The Herald*, 24 October, 1984

opposite

Two boys Dreaming at Marruwa 1987 Warlimpirrnga Tjapaltjarri

One of the first acrylic paintings produced by Warlimpirrnga, one of the nine Pintupi people who emerged from the Western Desert in 1984

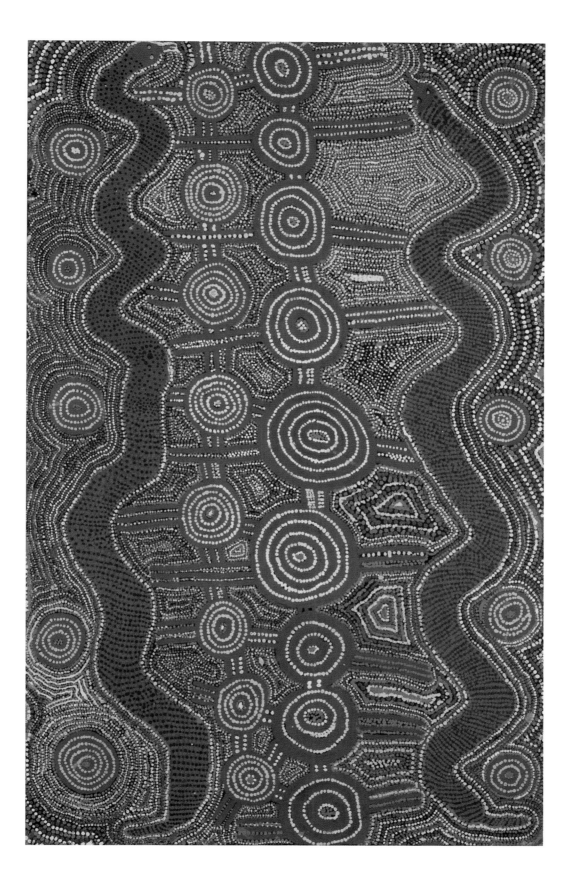

MEETINGS WITH STRANGERS

Jeremy Long

From 1957 to 1964 I took part in nine patrols to the Western Desert as an officer of the Northern Territory Welfare Branch. On these visits I had some twenty separate meetings with Aboriginal groups still living a traditional way of life. Every one of these encounters was exciting and interesting—for both parties. Each told us something more about these desert people and how they survived in their arid homelands. For them, our arrival provided a break in their routines as well as news from that other world where their relatives were living.

The first patrol to the Lake Mackay area was prompted by the arrival in 1955 of a party of men who had walked into Mount Doreen cattle station, north-west of Alice Springs. The Northern Territory Administration decided to see how many people were living out there and whether help of any kind was needed. A few weeks before the expedition was mounted in June 1957—two men and a boy had walked into the station—perhaps to find out why no one had yet come to visit them. They were persuaded to stay and act as guides for our party, and their presence seemed to guarantee success in finding people.

We were equipped with Landrovers, and a larger four-wheel-drive truck which allowed us to take along other Aboriginal men who knew the country to the west and were keen to revisit it; three of them brought their families, making it a substantially Aboriginal expedition. The slow progress of the convoy for the first three days provided opportunities to establish friendly relations with our guides, despite the lack of a common language.

After three days' travel, the convoy halted, and a party drove off to search to the south and west. The men who had walked into Mount Doreen showed us the rock-hole where they had parted from their families. We later found food and implements stowed in a tree, apparently left for their use.

The sudden appearance of strangers could cause alarm so we adopted the practice—learnt from our guides—of setting fire to clumps of spinifex when approaching an area that might be inhabited. The clouds of black smoke would not only announce our presence but invite a reply. When our guides fired the spinifex on the morning of the fifth day, we saw five separate 'smokes' rise up

opposite

Possessions left near Ilpili, Ehrenberg Range, by Pintupi people who walked into Haasts Bluff, circa October, 1956

to the west. After driving another eight kilometres, the guides hurried off over a sandridge. They soon reappeared, leading an old man and two boys to meet us. They all climbed aboard and we drove a little farther to their camp, where we were introduced to some women and children. In a space cleared of spinifex, low windbreaks sheltered depressions in the sand that formed their sleeping places. They drew water from a meagre well dug in the sand near the camp. Four families were supporting themselves here using only the tools they could make themselves. They carried no excess weight, but all seemed well and the food they had left in the tree thirty kilometres to the east showed that they could produce a small surplus.

We learnt that three members of this group had visited Mount Doreen station; for the rest, we were the first white people they had seen. We had lunch with these people and offered them food, but our main contribution was the return of the men and the boy to their families.

Our Warlpiri interpreter helped explain our visit and intentions. We were politely and cheerfully received, but our questions and much of our behaviour would likely have seemed ill-mannered, intrusive and inappropriate. As the junior member of our two-man Welfare Branch team, it was my job to ask about their names and relationships, and to estimate the ages of the eleven adults and nine children in the group. Dr John Hargrave, the medical officer in our party, wanted to make a superficial examination of their health and they tolerated this procedure, and my questioning, with good humour.

The whole group later moved north to the waterhole, Kimayi, where we set up a base camp. It was there that we met a man who had lost his right leg below the knee from a spear wound, but was able to move briskly about with the help of a long stick.

For nearly two weeks we visited waters farther west and south without seeing any response to our fires. Heavy rain poured down after we reached the Lapi Lapi rock-hole, near Lake Hazlett. This delayed us for several days and was likely to prompt any groups in the area to scatter to ephemeral waters. Our guides encouraged us to make for a rock-hole in a low rocky range north-west of Lake Mackay. South of there we found another group and gave them food and offered gifts of tinned beef, flour, matches and knives. Our guides had already conjured up shirts for each of the men, though the oldest of the three declined to try his on. We took photographs and recorded genealogical details. As we had already ventured well into West Australia and time was running out, we started on our return journey that afternoon.

In retrospect it is clear that this first patrol into the Western Desert was the one that was arranged in the most diplomatic fashion. We were in effect approaching as invited guests, accompanied by some of our hosts.

Later in the year I led a much smaller party west from Haasts Bluff to check whether there might be more people in the country to the south of Lake Mackay. With the help of our Aboriginal guides, we found a family living near the West Australian border. It was early November and very hot. The people were resting in the shade when we walked into their camp. Alarmed at first at our sudden, unheralded approach, the two men soon settled to talk. After some time one of the guides walked back to fetch the vehicles. The wives of the men had not been suitably warned and, when they heard the Landrovers coming, they ran off to hide with their children and were not seen again.

We spent the rest of the afternoon and evening talking with the men and cooking and eating the kangaroo that we had shot that morning—a rare treat in this region. The well, Yarannga, was deep, and in the damp sand at the bottom, three dingo pups were asleep. I remember being struck by how bright and alert the younger man's eyes were and how extraordinarily straight his back

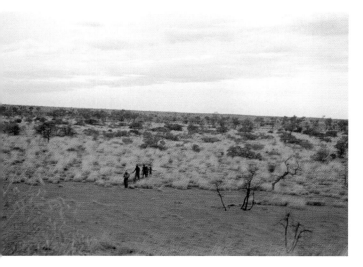
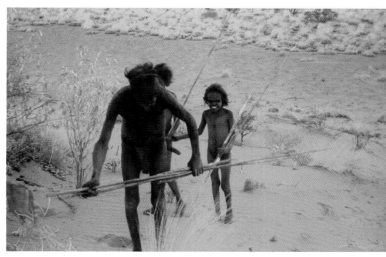
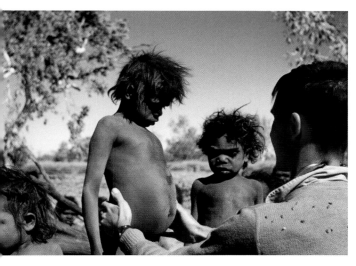
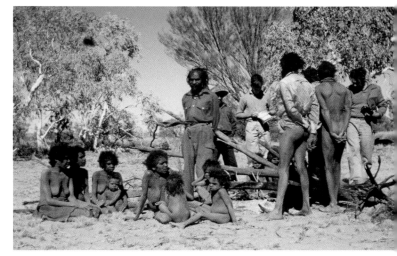

was. Living close to nature clearly had its advantages. He offered next day to lead us to another water, Yumarri, where we might find another group. But there we saw only distant smokes to the west. This young man, later known as Tim Payungka Tjapangarti, wanted to visit his mother, who had walked into Haasts Bluff a year earlier, so we gave him a lift to the settlement on our return.

The next winter I took Tim back beyond the Kintore Range so that he could rejoin his family. I remember him leaving us with a load of supplies on his head and disappearing over a sandridge. Another man who had come with us, Uta Uta Tjangala, joined Tim in the search for his family. Later that year they all walked the 300 kilometres back to Haasts Bluff, with another family. Both Tim and Uta Uta later became central figures in the Western Desert art movement.

My next encounter came four years later in June, 1962. In 1960 another Welfare Branch party had found graded roads being made from the south to the Kintore Range and beyond by a team led by Len Beadell for the Weapons Research Establishment (WRE). I was then working as a research officer with the Welfare Branch and it seemed worthwhile to go out and see what impact this new road and its users were having on the people of this area.

We drove out on an exploratory run, taking along a young man, George Tjungurrayi, who had recently walked into Papunya to visit his relations there. Some twenty kilometres over the West Australian border, two boys ran out and stopped us. They were soon joined by two men, brothers, and they all climbed aboard to take us to their camp in low hills about five kilometres north of the road.

There we met the wives of the two men and several other women and children, thirteen people in all. Only a few minutes after our arrival, a man—later known as Fred West Tjakamarra—and two youths, accompanied by a dingo, walked into the camp. He was rejoining his wife, having left his younger wife with her parents near Yumarri some seventy kilometres to the west.

We had some kangaroo meat to share with these cheerful people that evening, but they seemed well supplied with food. The hills sheltered a sparse population of rock wallabies and echidna and we saw that one woman had an echidna in her coolamon. We learnt that an older woman had recently lost her husband when he had pursued one of these creatures deep into a narrow cave and had been trapped, unable to back out.

Next morning we drove 170 kilometres west to the end of the cleared road where a survey party had sunk a well (Jupiter Well). Warm ashes and tracks showed our guides that people they knew had spent the previous night there, but we saw no one. We then headed back east, planning to return in a few weeks.

On our return, we established a base camp at Dovers Hills with the group we had seen previously. In our absence, two messengers had visited from a group living to the south-west and we decided to try to make contact with these people. Walter MacDougall, the WRE patrol officer from Woomera, joined us and we drove south and west beyond Yarannga into dense sandridge country. Next day, as we struggled slowly through the sandridges, putting up smokes and seeing other smokes to the south, we came upon an old man and his young son, who had just caught and killed a feral cat. We camped with them that night and learnt that this man had been with a group that had walked south to the Warburton Mission several years earlier. After his wife had died there, he had decided to return. After meeting two other families in the area, we started back to base camp.

After another visit to Jupiter Well—again deserted—we drove back to Papunya, having spent the best part of two months in these explorations. A small boy had been badly burnt and we took him with us for medical attention.

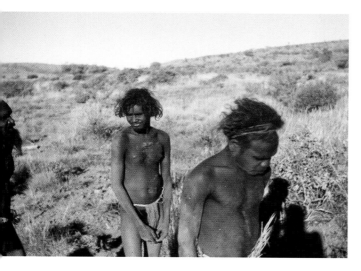 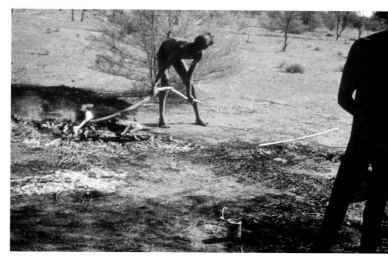

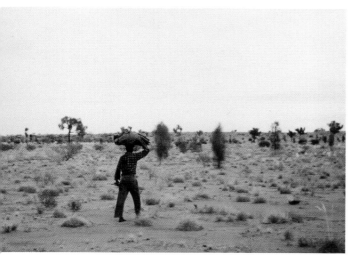 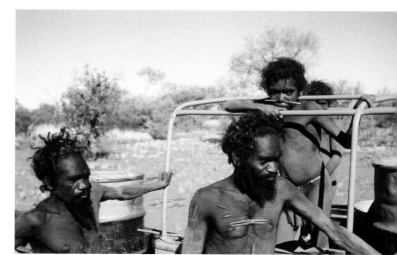

I made another two journeys the following year. A cameraman, Frank Few, joined us to film the patrol for an ABC documentary and a Darwin journalist, Doug Lockwood, came to report on the work. Rain had fallen in March and April, encouraging three of the families that we had met to walk into Papunya, where they had arrived a few weeks before we set out. When still well to the east of the Kintore Range, we sent up a good black smoke and soon our guides spotted another to the west which indicated that someone else had started on the walk to Papunya. Thirty kilometres farther on we saw footprints on the road and turned off to Willi rock-hole where we found two women, each with a small child. At sundown their husband, Fred West Tjakamarra, walked in with his day's catch of a rabbit and some lizards. We decided to spare these people the long walk and arranged for them to ride in on one of our trucks.

Before we reached Jupiter Well, we saw fresh tracks on the road and halted while our guides walked into a nearby well. While we had lunch by the road, a young lad of about fourteen appeared and just then our guides signalled that they had found people at the well. Driving the Landrovers over three sandridges, we came to Wutungu Well and met Anatjarri Tjampitjinpa, his two wives and three children. Anatjarri was keen to join us in looking for others. He volunteered to search to the south and returned to Jupiter Well next day with an old man whose wife and three daughters and their young children followed a little later. Their skinny legs and distended bellies indicated that these children were much less well nourished than those we had seen to the east. The handful of tiny mountain-devil lizards that the old man held offered further evidence that conditions were difficult here at a time when Central Australia had already had five years of drought conditions.

On a second visit three weeks later, near Wutungu, we met the husband of this old man's three daughters, along with a woman who had recently survived, with her child, when her husband had perished on a long walk between waters. We gave penicillin injections to cure three of the young children of the bad sores they had, and provided some vitamins and high protein foods.

Apparently a dingo that we had seen with Anatjarri actually belonged to this man we met near Wutungu. It appeared that the dingo had chosen to stay with Anatjarri in that area rather than following his master. When the two met again, after spending perhaps months apart, we witnessed man and dog embracing enthusiastically—a display of emotion of a kind never seen when husbands and wives met after an absence. Not every group we met had a dingo, but the dingos we did see in camps seemed to be less well fed than those we saw running wild.

On the way back, we found a small girl at Wirulnga rock-hole. She was minding her smaller sister and holding two dingo pups—August being the puppy season—while the mother dingo was heard howling up in the rocks. We made tea and waited with the girls until their mother and older sister returned from their foraging, followed later by their father with a collection of lizards strung from his hairstring belt and headband.

By the end of that month, it was clear that many of the people were keen to move out and link up again with their relatives at Papunya. The exodus from the region had limited their social contacts and left young people without suitable partners. We suggested that transport might be arranged for people interested in making the move and that bores might be sunk to provide reliable water points along the road; both propositions were well received by the Administration. Later that year the authorities agreed on a joint patrol conducted by Western Australian, Northern Territory and WRE officers and that a truck be taken out to transport any who wished to move to Papunya.

In April our truck was hailed by a party of women and children gathering grass seed and bush tomato near the road, not far from the present site of the Kiwirrkura community. We took them to

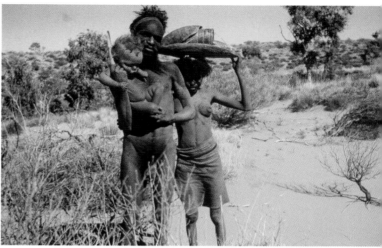

Wala Wala Well, in the nearby Pollock Hills, meeting two of the men of the group on the way. One of these was so eager to meet us that he had already come 100 kilometres from the Jupiter Well area to make sure of it. Making a base camp here, we drove west to contact groups north and south of the road. All of those we met were ferried east to Mount Liebig. There we hoped to set up a temporary camp where they could settle for the time being, continuing to forage for themselves, but the spring there seemed inadequate. Our guides were keen that they should all go onto Papunya and so they did.

The WRE patrol officers continued making occasional visits to the area and fifty more people came in with them over the next two years. But we knew that the depopulation of the area was not complete, because one small group remained, well to the north of the road, led by a man who had previously gone into the Balgo mission but had walked back, determined to resume the bush life. He would have no difficulty in either making his way back there or taking the eastern route to Mount Doreen station, if and when he chose to do so. Twenty years later, after his death and after others had returned to the country when the Kiwirrkura community was established in 1982, these nine people finally renewed contact with their relatives.

left to right

John Tjakamarra approaching the patrol party in sandridge country south of Mt Webb, 8 July, 1962

John Tjakamarra, child and wife Minyantu, 8 July, 1962

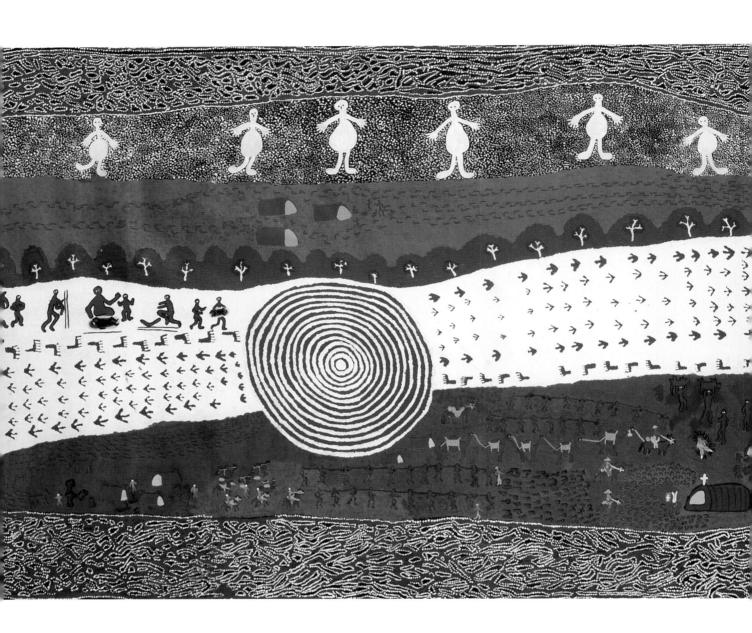

WHEN WE FIRST MET WHITE PEOPLE
Five biographies

Philip Batty

This painting represents the history of first contact between Aboriginal people of the Western Desert and Europeans. The top and bottom edges depict sandhill country around Pirrmunga, in Pintupi country. The row of white figures represents a mythic figure, Pungkalangu, who killed and devoured people—a metaphor for a white man called Kungki, who was reputed to have shot and eaten Aboriginals.

The row of trees and mountains represents the Macdonald Ranges. The movement of people from the bush to Hermannsburg Mission and Haasts Bluff is depicted using footprints, camels and horses, descending from the top to the lower area. The earlier police practice of chaining Aboriginals who were caught spearing cattle, is also depicted here. The bottom right area represents a church service at Haasts Bluff. The large roundel in the centre represents Wintjiya Napaltjarri's father's dreaming site, Walukarritji, west of Kintore range.

First Contact 2005
Wintjiya Napaltjarri Morgan,
Kathleen Whisky Nungarrayi,
Colleen Whisky Nampitjinpa,
Ngoia Napaltjarri Pollard
and Ulkalara Napaltjarri

Freddy West Tjakamarra

'I thought the tins might contain flesh of Aboriginal people...human meat...We thought that some evil spirits had killed the meat and left it for us...whitefellas love those tins but we buried them...we didn't know what it was...we were frightened of what it might be.'

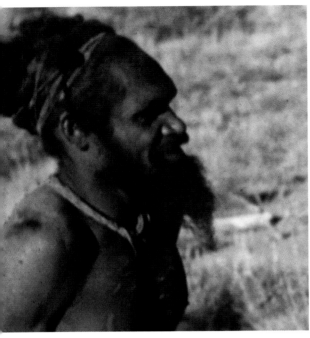 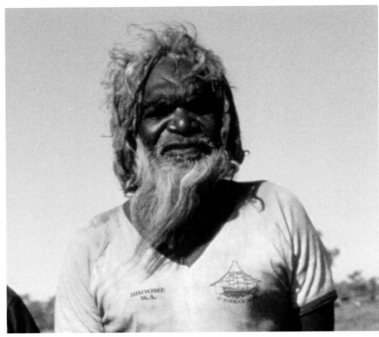

Freddy West's first experience of white people came in 1961 when he discovered tins of beef discarded by a waterhole. The tins had been left by surveyors working in the area that year.

Later a patrol led by Jeremy Long encountered Freddy near Dovers Hills, on the West Australian border. The patrol's interpreter, Nosepeg Tjupurrula, told Freddy that his relatives had moved to Papunya. When the patrol returned a year later, Freddy asked to be taken to Papunya. In August 1963, he entered a new way of life.

'When I got to Papunya, I was shy...there were so many people, they looked like ants...all our relatives welcomed us, the new bush people...I was overcome by it...I was so happy to see them...I thought, Yes, it's true, they are alive.'

Freddy moved with his family to Kintore (Wallangurru) in the early 1980s and then to Kiwirrkura, closer to his traditional country. He was a major figure in the Western Desert Art Movement, and his work is represented in major art institutions in Australia. Freddy West died in 1994.

Mantua Nangala

'We were on the other side of a sandhill near Likilnga when we heard a noise.'

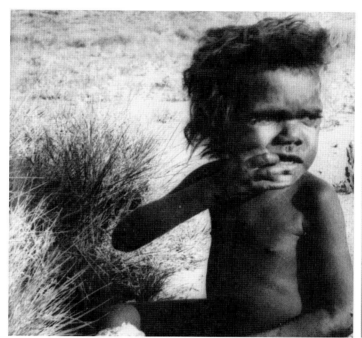 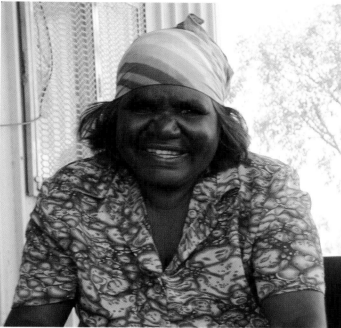

One day in 1963, Mantua Nangala was gathering bush tucker with her mother at a waterhole near Kiwirrkura, in Western Australia. She was about five years old at the time but can still remember hearing a strange sound in the distance.

left to right

Mantua Nangala,
age five, 1964

Mantua Nangala, 2004

> *'We were on the other side of a sandhill near Likilnga when we heard a noise that we hadn't heard before...we were frightened and hid in some bushes...we couldn't understand...my sister was crying...then we saw a motor car.'*

The vehicle belonged to a Welfare patrol and it heralded the arrival of white people into Mantua's life. The patrol was accompanied by an Aboriginal man, Nosepeg Tjupurrula, who spoke her language. He told them not to be frightened and offered Mantua some unfamiliar food. A year later Mantua and her family were taken to Papunya, at the request of her father, Anatjarri Tjampitjinpa.

Mantua went to school at Papunya and then trained as a health worker at the Kintore (Wallangurru) Health Clinic. Later in life she took up painting and storytelling. In recent years, Mantua has travelled overseas, talking to enthusiastic audiences about her life and art.

Mick Namarari

'I saw the tracks of a raiding party...then we found my father...speared to death.'

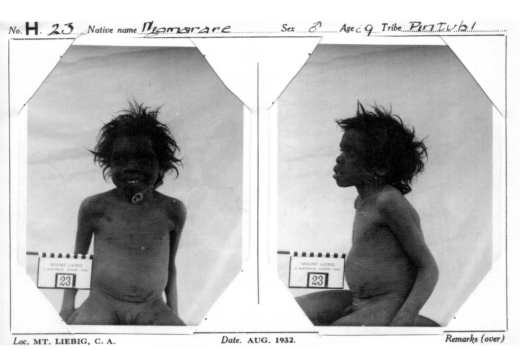

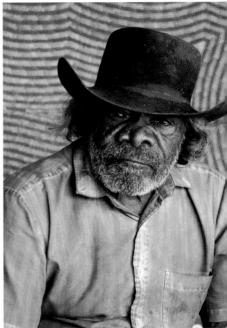

No. **H. 23** Native name *Namarare* Sex ♂ Age *c 9* Tribe *Pintubi*

Loc. MT. LIEBIG, C. A. Date. AUG. 1932. Remarks *(over)*

left to right

Photo identification
for Mick Namarari,
age nine, 1932

Mick Namarari, 1991

Mick Namarari knew a life of tumultuous change. He first encountered Europeans in 1932 when a University of Adelaide expedition arrived at Mount Liebig. A few years later his father was speared to death by an Aboriginal raiding party (warrmala).

> *'One day, my father went off for game...but he did not return that night...next morning we followed his tracks...we saw eagles and crows above and thought, he might be there. We went over and I saw the tracks of a raiding party...then we found my father...speared to death. My grandmother...lit a big fire and threw herself into it.'*

In about 1940 Mick's family walked into Hermannsburg Mission, where they received rations. He eventually found work as a stockman near Kings Canyon, where he experienced another harrowing event after Aboriginal men had speared some cattle.

> *'That white boss said to me, "If you see those Aboriginal men again, shoot them." All of us had revolvers then. Later, that boss shot some Aboriginals who had been spearing and eating bullocks. He used to burn the bodies in a cave. Then he said to me, "You are the leader, you look after the cattle now".'*

Mick lived for a while at Papunya, then moved to Kintore (Wallangurru) and finally to an outstation near his original home of Manpi. He went onto establish an international reputation as a painter. His *Bandicoot Dreaming* won the 1991 National Aboriginal Art Award. Mick died at Papunya in 2001.

Johnny Warangula Tjupurrula

'When I saw the aeroplane...I thought it might be a...devil bird...then white men came out of its belly.'

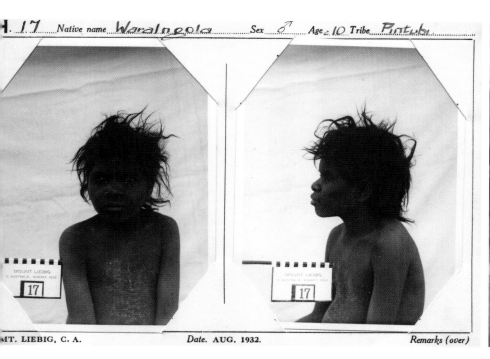

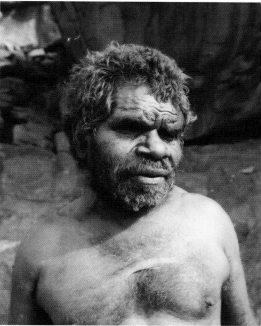

In 1930, Donald Mackay led an aerial survey team into the Western Desert, establishing a camp and airstrip at the remote Ehrenberg Ranges (Ilpili). Johnny Warangula Tjupurrula's family were camped near the ranges and had never seen white people before. Overcoming their fear, they went to meet the survey team, who proved to be friendly. But when a plane arrived from Alice Springs, their fear returned. Warangula was about seven years old at the time.

> *'When I saw the aeroplane, I thought it might be a giant eagle [walawurru] or devil bird [tjulpu mamu]...we were frightened and didn't know what to do...some of the men grabbed their spears...others climbed up into the trees...my uncle tried to kill it by singing a magical song [yinkarra pikantanu]...we all ran away...later, we saw the aeroplane land, still thinking it was a devil bird...then white men came out of its belly.'*

Two years later, Warangula and his family walked into Mount Liebig (Amundurrunga). Here they would be studied and photographed by the scientific team from the University of Adelaide. The identification photograph of Warangula was taken by one of the scientists, Norman Tindale. A journalist at Mount Liebig later described how some of the Pintupi people entertained the scientists by mimicking the sounds and movements of an aeroplane.

Johnny Warangula Tjupurrula was one of the founding members of Papunya Tula Artists, whose paintings are considered part of the canon of the Western Desert Art Movement. He died in Alice Springs in 2001.

left to right

Photograph identification for Johnny Warangula Tjupurrula, age ten, 1932

Johnny Warangula Tjupurrula, 1979

Mitjili Napanangka

'We went to a place called Lappi Lappi and they took photos of us.'

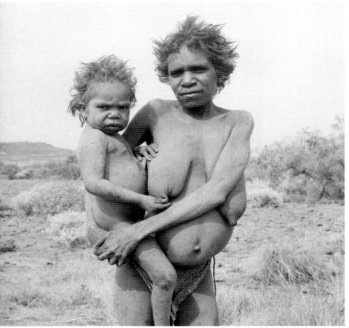

left to right

Mitjili Napanangka
carrying her son, Mamunya Lyle
Tjakamarra, 1957

Mitjili Napanangka, 1999

Mitjili Napanangka was a young woman when a party led by Donald Thomson arrived in her country in 1957. She had not previously seen Europeans but had heard about them. A few years prior to Thomson's visit, some of Mitjili's relatives had visited the remote mission station of Balgo, but they had returned to the bush. Thomson found Mitjili's group north of Lake Mackay in Western Australia. She remembers her encounter with Thomson's party.

> *'Some whitefellas came here...we saw them come across the plain in cars...we hid in the soakage but they came and found us here...they said, "come to the water"...we went to a place called Lappi Lappi and they took photos of us...it was good without white people, but they gave us food.'*

Not long after these events, Mitjili and her family walked east of Lake Mackay until they arrived at Mount Doreen cattle station. They moved to the government settlement of Yuendumu, a large Walpiri community. Over the following years, Mitjili spent more time with her Pintupi relatives, living in Nyirrpi, Kintore (Wallangurru) and Kiwirrkura.

Today Mitjili lives with her extended family, both Aboriginal and non-Aboriginal, in Alice Springs. She is in high demand, providing advice to film crews, botanists, zoologists and others seeking her expert knowledge of the Western Desert.

Benny 'Doctor' Tjapaltjarri

'I took a stick and licked it..."Oh! This is good," I thought.'

Benny Tjapaltjarri, 1996

During the 1930s and 40s, missionary parties from Hermannsburg travelled into the Western Desert, making contact with remote Aboriginal groups. Benny Tjapaltjarri met one such group near Putarti Springs.

> *'The missionary [ingkata] came in from the north with a team of camels and we went over to him...he gave us food and we gave him things like shields, boomerangs, spearthrowers'*

Benny and his family had never tasted European food before, but it had an immediate impact. He later recalled receiving a large tin of jam.

> *'I opened that stuff and had a look, then took a stick and licked it..."Oh! This is good," I thought...I drank the jam and finished it off...I said, "Leave that old bushtucker, this food is for us!".'*

Attracted by the new food, Benny and his family visited the settlement of Haasts Bluff, but returned to the bush soon after. In the following years he moved back and forth between the settlement and his traditional lands near Kintore (Wallangurru), but eventually decided to move to Haasts Bluff permanently.

Later in life Benny employed his skills in traditional medicine at community health clinics in Papunya and Kintore, helping to bridge the cultural gap between the white staff and the Aboriginal patients. When a new clinic was opened at Kintore, it was named in his honour. Benny died in 2003.

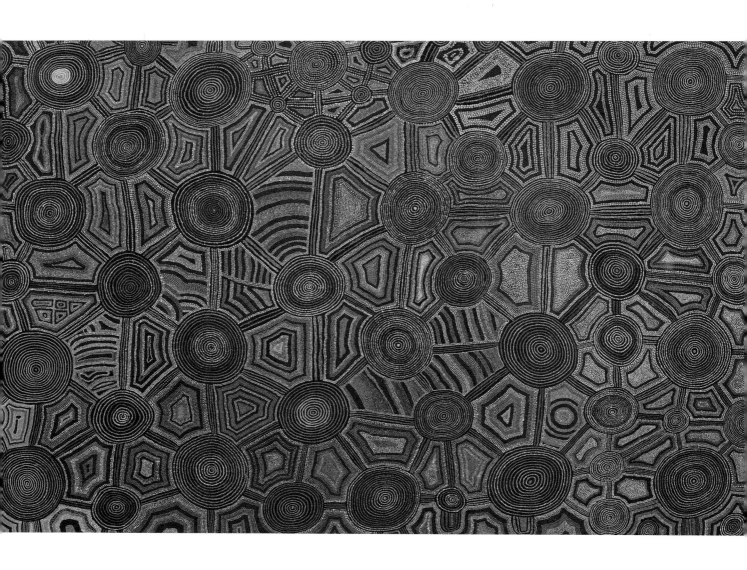

A BIG CANVAS
Mobilising Pintupi Painting

John Kean

In 1989, Uta Uta Tjangala told me that he wanted to be remembered, not just for his ceremonial authority, but as an individual who fought for his family and for Yarnangu (people of the Western Desert).[1] The paintings that resulted from his conviction are more than an expression of his personal power, they also represent the collective destiny of a people.

Uta Uta was the most exciting, explosive and playful of the Pintupi artists to emerge from the isolated settlement of Papunya in the early 1970s; a personality of mythic proportions that made him the equal of everybody he met. Totally ethnocentric, shockingly egocentric, touchingly sensitive and often hilariously funny, his paintings remain as a transcendent legacy of the collision between traditional Western Desert culture and government policy.

Uta Uta's paintings stretched the constrained and stylised bounds of Pintupi art. The canvas was not big enough to contain his huge sense of self; the paints were not bright enough to express the significance of his ancestral country. His paintings burst at their rectilinear edges. Uta Uta's artistic output can be seen as an individual account of his life, his belief and his aspirations.

Untitled (Jupiter Well to Tjukula) was painted in February, 1979. At that time Uta Uta was camped at Kultukutjara (Docker River) following a period of extensive travel around the fringes of the desert, reconnecting with the Western Desert diaspora. Such was Uta Uta's charisma that I risked my life, and that of my companions, travelling a thousand kilometres in the heat of summer, just to get him the canvas to produce this work.

When we limped into Docker River, after having lost a wheel 50 kilometres short of the Tjukula turnoff, Uta Uta was glad to see us, but unsurprised, for it was natural that I should be drawn to him from across what was then one of the least used tracks in Australia. But my desert adventure paled into insignificance in comparison with his own heroic exodus from his country, on foot and in the middle of a prolonged drought. On reaching the ration station at Haasts Bluff he settled his family, and then he immediately turned around, trekking some five hundred kilometres into the sandhill country to locate and collect other relatives and return with them to the apparent security

opposite

Untitled 1975–1976
Uta Uta Tjangala

This work represents a large area of land stretching over 300 kilometres from Jupiter Well in Western Australia to Tjukula on the Northern Territory border. While depicting several drawings, it is mainly concerned with the travels of the mythic *tingari* men who performed secret sacred rituals during the dreaming, shaping the land in the process.

above
Uta Uta Tjangala

opposite

Old Man's Dreaming
Uta Uta Tjangala

This painting depicts the
important dreaming site of
Yumari, a rocky plateau
west of Kintore (Walungurru).
Here, an old man, Yumari,
had a sexual liaison with a
woman of the wrong
kinship section.
The figure represents
Yumari and the overline
shapes, the indentations
in the rocky plateau and
several characters associated
with the dreaming story.

of the ration station. Retelling this story more than two decades after the event he raised his hands above his head, declaring: 'I am the winner!'[2]

A permanent art from a nomadic people

In 1971 when the desert painting phenomenon first emerged, the Pintupi were stuck on the western fringes of Papunya at the so-called 'Piggery Camp'. They had experienced shocking mortality since leaving the desert and many of the most recent arrivals were still immobilised by culture shock. This was the nadir of Pintupi history. The story of the painting movement that was to follow is inextricably connected with their return to country.

Looking back with the advantage of thirty year's hindsight, it is not surprising that the Aboriginal acrylic art movement had its origins at Papunya. Albert Namatjira, the greatest of the mid-20th-century watercolour painters had lived there shortly before his death in 1959. Young stockmen like Kaapa Tjampitjinpa, Tim Leura and Clifford Possum had encountered Namatjira as a senior relative and as a mentor. Kaapa went on to make a major contribution to the Honey Ant Mural on the wall of the Papunya School and just as significantly his painting *Gulgadi* won the Alice Springs Art Award in 1971.[3] From that moment it was clear that good money could be made from the painting business.[4]

Papunya is at the point of convergence of three major linguistic groups: Arrente, Warlpiri and Western Desert and, as such, is a melting pot for ideas, histories and ceremonial conventions. While daily life was dominated by conflict, the men's painting room, facilitated by Geoff Bardon, was a place where common interests could be shared and curiosity could prevail over hopelessness. Soon Pintupi men, such as Uta Uta and Anatjari Tjakamarra joined their peers from the east in the joy of painting ancestral images on board. Initially painting gave these men a vehicle to revisit, in their creative imaginations, the sites to which they were connected by birth, inherited interest and historical event.

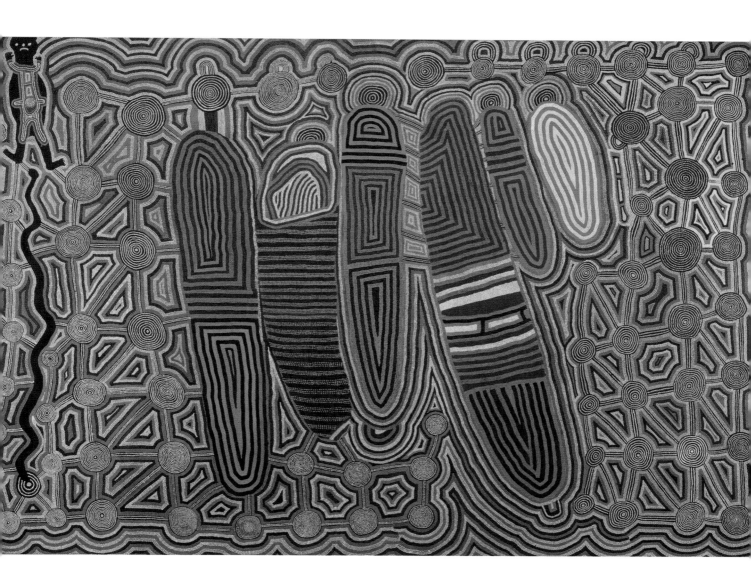

For the non-indigenous witnesses who took an early interest in the painting phenomenon, the sites evoked in the paintings—Kaakuratintja, Tjukula, Mitukatjirri, Umari—were far away, in a sea of sandhills, way out on the West Australian border. Indeed, the few roads through this country had deteriorated since their creation two decades before, to the point where their potholes threatened to swallow car wheels and spinifex, growing in the middle of the road, soon blocked unprotected radiators. An increasing number of Pintupi artists began painting those places with which they yearned to be reunited. The now famous small boards, with spidery lines and cryptic iconographs, were some of the first rumblings of their intention to get back to country.

Gradually a small industry grew up around Papunya painting, driven by the restless energy of the artists and the commitment of a few whitefellas who saw in the paintings compelling renditions of traditional Aboriginal culture. Following the creation of the Aboriginal Arts Board by the Whitlam Government, Papunya Tula was incorporated and received operational funding.

Pintupi men's painting camps

At the same time the Pintupi had established outstations at Yalumbra Bore, Yai Yai and Wara Wiya towards their ancestral country but still within the gravitational pull of Papunya.[5] Here men gathered at painting camps and contemporary Pintupi art, based on collective vision and shared cultural identity, took off on its own independent trajectory. Then, as now, most Pintupi paintings represented the adventures of the Tingari (ancestral men and women) as they travelled the country instructing initiates and encountering other ancestral beings.

Sale of the work relied on a national network of government-run Aboriginal arts and crafts outlets in the state capitals, Alice Springs and Darwin. This was a time before there was a popular acceptance of Aboriginal art and the demand for 'dot paintings' had not been awakened.

In 1977, when I was engaged as the Art Adviser for Papunya Tula Artists, commissions for the first large works had just been received. These canvases, (each 3 x 4 metres in size) offered the artists new opportunities. Their scale approached that of the ceremonial ground itself, giving the works added significance. This scale also enabled visual ideas to be elaborated, with the potential to depict more than one ancestral narrative on a single canvas evoked as several mythic beings interacted across a vast terrain.

While these paintings now sit vertically on the white walls of state galleries, they are essentially performative works, painted flat on the ground, echoing the ceremonies they represent. Their manufacture was an event in itself, most often painted by a group of men, dotting and singing for over a week as the painting emerged.

The creation of most of these large works followed a similar pattern. On reaching the outstation I would put together the frame and stretch the canvas. The commissioned artist would typically apply a red ochre or black undercoat straight away. By this stage a group of men would gather and begin to discuss the stories to be represented. The commissioned artist would paint the sets of concentric circles (representing specific locations) and interconnecting network of lines (representing travel between those places). Gradually more senior men associated with the country would comment on the composition, sometimes suggesting modifications and additions. Then two or three men would apply dots, between the lines, to emphasise these major iconographic elements. Gradually younger men and others not so closely associated with that country would move forward and take up brushes. Under the guidance of the principal custodians, they would fill in the sets of concentric dotted bands between the site and path motifs. By this stage the energy

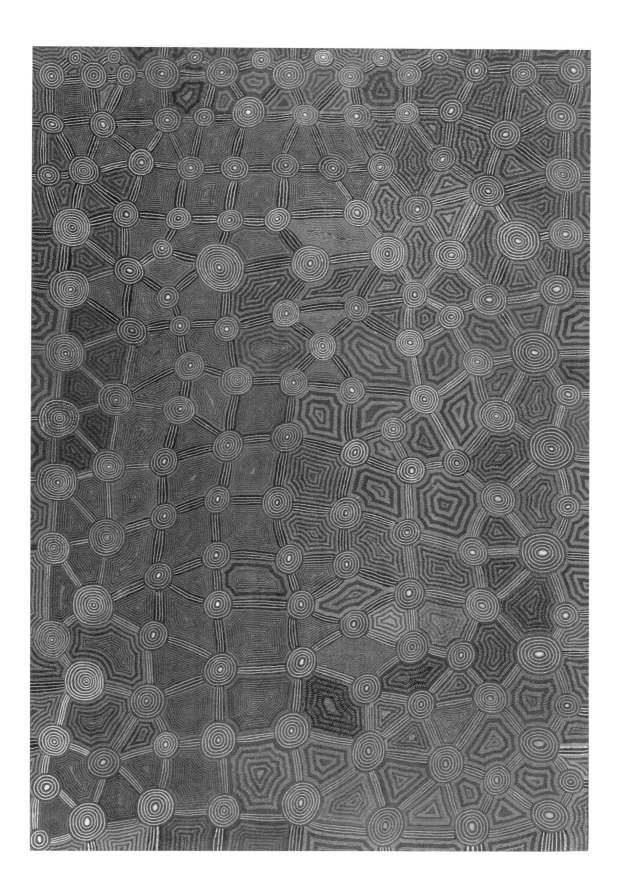

around the paintings would be pulsing with the cadenzas of song, rising and falling in a sustained rhythm for several hours over several days.

The visual effect of these large collaborative works is scintillating, with a restless overall composition punctuated with pulsing sets of concentric circles, each the same but different. The negative spaces, between the lines and circles, become like a piece of agate sawn in half with a fingerprint of a particular artist apparent in the rhythm and density of the dotted bands. In some areas of the canvas six or seven adjacent areas might be completed by the same hand, while in other areas a single patch will jump out visually as different. There are few parallels in western art for these great paintings, perhaps the cathedrals of medieval Europe are comparable, created by a secession of stonemasons, working under the verbal instructions and guided by the constancy of liturgy.

Just as importantly, payment for canvases of this scale was the then substantial sum of $1000. While in the current market conditions this is a relatively trifling amount, at that time it represented the largest amount attainable by Pintupi men by any means. And it was just enough to buy a second hand car from one of the dodgy used-car lots circling Alice Springs. So on receipt of the cheque for a completed work, an artist would rush to town, buy a car and if all went well return to Papunya or its outstations. For Pintupi men the car represented the opportunity to travel independently to see relatives, to go hunting and if the season was right, to join one of the ceremonial processions that travelled widely around a vast desert circuit each summer. The purchase was just as often followed by disappointment, as the car failed to make the return journey and the deflated artist was forced to make a tough decision between pursuing a case through Aboriginal Legal Aid or returning home by whatever means possible. Each of the large canvases painted by Pintupi artists during this period has a story, often about motorcars, court appearances and close shaves on the road.[6]

Big canvas, big country

Untitled (Jupiter Well to Tjukula) was created by many hands, but under the direction of Uta Uta who was then at the height of his ceremonial power and political influence. It represents six ancestral trails covering a vast swathe of country from Pinyarinya in the north to Tjukula in the south.[7] The painting is oriented with the grain of the country, dominated by parallel sand-dunes, running from west to east. The direction of the songlines corresponds to this rhythm, for the mythic beings, like the Pintupi, choose to travel along rather than up and over most of the sand-dunes. The painting covers an area much greater than Uta Uta's own country and includes the heartlands of at least five other men. The scope of Uta Uta's vision is greater than is typical in the Western landscape tradition, it stretches a distance of three hundred kilometres, well over the horizon and further than the eye can see. To european eyes, painting on this scale has become more comprehensible since the advent of satellite imagery.

The major songlines represented are from north to south:
Women going east
Tingari men and two women going north-west to Pinyarinya
Possum ancestors going west
Emu ancestors again travelling west, just slightly south of the Possums' trail
Another group of Tingari men coming from Kaakuratintja where many of their party had been killed by a hailstorm
A separate group of Tingari men who had been performing 'punyunyu' ceremonies at Tjukula

The large collaborative paintings created by Pintupi men in the 1970s and 80s were a compelling and portable expression of their desire to return to country. At the same time, men like Uta Uta made representations to non-indigenous settlement workers, visiting government officials and at more formal land hearings.

A change in Government policy in the 1980s saw the return of many Yarnangu to their country and the creation of new settlements and satellite outstations within the heart of the Western Desert. Transport between these communities improved immeasurably and many new artists, both men and women, in adjacent communities took up brush and paints to participate in what has become the most vital component of the desert economy. A new generation of artists continues to evolve new forms of expression.

Uta Uta and his peers at Papunya were the first indigenous artists to explore the new media of acrylic on canvas. In the process they also created one of the most significant schools of Australian painting. Uta Uta's paintings have been seen in major venues in Sao Paulo, New York, Madrid, Düsseldorf and Turin and have helped to shape the way Australian art is perceived internationally. On his return from Jigalong after two hard days' travel in the back of a ute, we sat together at Muyin, his outstation, back in the heart of his country. He looked past me with burning red eyes into the setting sun. Uta Uta was the winner!

NOTES

1 Uta Uta Tjangala in conversation with the author at Muyin in 1989.
2 Ibid.
3 *Papunya Tula Genesis and Genius* by Hetti Perkins and Hannah Fink. Exhibition catalogue. Art Gallery of New South Wales, Sydney, 2000, p305.
4 Vivien Johnson in conversation with the author in 2005, regarding the relative importance to the instigation of the painting movement, by the creation of the Papunya School mural and the prize money won by Kaapa Tjampitjinpa.

5 *Getting Back to Country: painting and the outstation movement 1977–79* by John Kean and *Papunya Tula Genesis and Genius* by Hetti Perkins and Hannah Fink. Exhibition catalogue. Art Gallery of New South Wales, 2000. pp217–23.
6 Uta Uta Tjangala purchased an old Holden bomb in 1978, it subsequently broke down on the way out of town and he returned to Alice Springs. Uncharacteristically, Uta Uta joined some countrymen for a drink. Breaking away from the group he knocked on the door of a group of similarly drunk off-duty policemen where they became

embroiled in a fight. Uta Uta, who was then in his late fifties, drew a knife in self-defence but was badly bashed. Following the court case, the judge then dismissed the case as a 'classic case of cultural misunderstanding'. The author heard two versions of these events from Uta Uta Tjangala and Dick Kimber, who had attended the court case in 1978.
7 Information based on an annotation of the painting UU79, dated 08.04.79 on Papunya Tula Artists letterhead prepared by the author after discussion with Uta Uta Tjangala.

BIBLIOGRAPHY

Albrecht, F.W., 'Hermannsburg from 1926 to 1962' in Leske, E. (ed.), *Hermannsburg: A Vision and A Mission*, Lutheran Publishing House, Adelaide, 1977, pp. 42–89.

Beadell, L., *Outback Highways*, Rigby Publishers, Adelaide, 1983.

Campbell, J., *Invisible Invaders*, Melbourne University Press, Carlton South, 2002.

Carnegie, D.W., *Spinifex and Sand*, Penguin, Ringwood, 1973 [1898].

Clendinnen, I., *Dancing with Strangers*, Text Publishing, Melbourne, 2003.

Davenport, S., Johnson, P. and Yuwali, *Cleared Out, First Contact in the Western Desert*, Aboriginal Studies Press, Canberra, 2005.

Davis, S., *Above Capricorn*, Angus & Robertson, Pymble, 1994.

Forrest, J., *Explorations In Australia*, Libraries Board of South Australia, Adelaide, 1969 [1875].

Gard, R. and E., *Canning Stock Route*, Western Desert Guides, Wembley Downs, 1990.

Giles, E., *Australia Twice Traversed* (vols I and II) Macarthur Press, Sydney, 1979 [1889].

Giles, E., *The Journal of a Forgotten Journey*, Corkwood Press, North Adelaide, 1999 [1880].

Gosse, W.C., *W.C. Gosse's Explorations*, Libraries Board of South Australia, Adelaide, 1973 [1873].

Grayden, W., *Adam and Atoms*, Frank Daniels, Perth, 1957.

Henson, B., *A Straight-out Man: F.W. Albrecht and Central Australian Aboriginies*, Melbourne University Press, Carlton, 1992.

Hilliard, W., *The People in Between*, Hodder and Stoughton, London, 1968.

Lockwood, D., *The Lizard Eaters*, Cassell Australia, Melbourne, 1964.

Mulvaney, J., Petch, A., and Morphy, H., *From the Frontier*, Allen & Unwin, St Leonards, 2000.

Peasley, W.J., *The Last of the Nomads*, Fremantle Arts Centre Press, Fremantle, 1983.

Rose, F.G.G., *The Wind of Change in Central Australia*, Akademie Verlag, Berlin, 1965.

Smith, E., *The Beckoning West*, Wescolour Press, Perth, 1979.

Smith, M.A., *Peopling the Cleland Hills*, (Aboriginal History Monograph 12), Aboriginal History Inc., Canberra, 2005.

Spencer, B. and Gillen, F.J., *The Native Tribes of Central Australia*, Dover Publications, New York, 1968 [1899].

Stirling, E.C., 'Anthropology' in Spencer, B. (ed.), *Report on the Work of the Horn Scientific Expedition to Central Australia*, Corkwood Press, Bundaberg, 1994 [1896], part IV, pp. 1–157.

Strehlow, T.G.H., *Comments on the Journals of John McDouall Stuart*, Libraries Board of South Australia, 1967.

Strehlow, T.G.H., 'Geography and the Totemic Landscape in Central Australia: a Functional Study', in Berndt, R.M. (ed.), *Australian Aboriginal Anthropology*, University of Western Australia Press, Nedlands, 1970, pp. 92–140.

Terry, M., *Sand and Sun*, Michael Joseph, London, 1937.

Terry, M., *Untold Miles*, Selwyn & Blount, London, 1928.

Terry, M., *Hidden Wealth and Hiding People*, Putnam, London [no date].

Thomson, D.F., *Bindibu Country*, Thomas Nelson Australia, Melbourne, 1975.

Tindale, N.B., *Aboriginal Tribes of Australia*, Australian National University Press, Canberra, 1974.

Tonkinson, R., *The Jigalong Mob: Aboriginal Victors of the Desert Crusade*, Cummings Publishing Company, Memlo Park, California, 1974.

Warburton, P.E., *Journey Across the Western Interior of Australia*, Hesperian Press, Victoria Park, W.A., 1981 [1875].

PHILIP BATTY

Philip Batty is Senior Curator for Central Australian Collections at Museum Victoria. He cofounded the Central Australian Aboriginal Media Association (CAAMA) in 1980, which established the first Aboriginal radio and television services in Australia. He was the Director of the National Aboriginal Cultural Institute (Tandanya) from 1991 until 1993 and has produced television documentaries for the ABC, SBS and Channel 4 (UK). He has contributed to various anthologies, with interests centring on cultural interaction, visual anthropology and indigenous political organisation. He gained a PhD in anthropology and political science in 2003; was the recipient of a Churchill Fellowship in 1984; Winner of the Northern Territory History Award in 1992; the UNESCO (Canada) McLuhan-Teleglobe Award in 1994 and the Australian Screen Directors Association's Cecil Holmes Award in 1997.

JEREMY LONG

Jeremy Long is an historian and former Commonwealth public servant who worked in the Northern Territory from 1955 until 1968, as a field and research officer and with the Department of Aboriginal Affairs until 1982. He worked at the Haasts Bluff and Papunya communities and in particular with the Pintupi people on the communities and in their homelands to the west. Jeremy Long's published works include *Aboriginal Settlements: a Survey of Institutional Communities in Eastern Australia* (1970) and *The Go-Betweens: Patrol Officers in Aboriginal Affairs Administration in the Northern Territory 1936–1974* (1992). He has also published several articles on aspects of Aboriginal contact history.

R.G. (DICK) KIMBER

R.G. (Dick) Kimber was born in 1939 in Freeling, South Australia. He is married with two children. Since 1970 Dick has lived in Alice Springs where he was a teacher. He was the first Sacred Sites officer in Central Australia, was an Aboriginal Curriculum Development officer and from 1976–78, a senior coordinator of Papunya Tula Artists. Since 1981, he has written numerous books and articles, worked as a historian and a house-husband. He has assisted with land claims and was the historian for the Arrente Native Title Claim, Alice Springs.

Dick considers it a privilege to have travelled with Warlpiri, Pintupi and other Western Destern peoples in their Tanami, Great Sandy and Gibson Desert homelands, since the 1970s. He is a life member of the Brighton Surf Life Saving Club, Wests Football Club (Alice Springs) and the Central Australian Football League. Dick is often seen having a yarn outside the Alice Springs Post Office.

JOHN KEAN

John Kean was the 2004 Thomas Ramsay Science and Humanities Scholar. His career spans both visual art and museums sectors. In the late 1970s, John was Art Advisor for Papunya Tula Artists, a collective of central Australian painters who irreversibly changed the face of painting in Australia. Prior to taking up the position of Exhibitions Coordinator of the Fremantle Arts Centre, he was the inaugural Exhibitions Coordinator at the National Aboriginal Cultural Institute (Tandanya) in Adelaide. In 1996, John joined Museum Victoria as Creative Producer and has been a driving force behind many of the most innovative exhibitions and displays. His most recent exhibition was *Treasures, Museum Victoria Celebrates 150 Years*. John has written extensively on indigenous art and the representation of the indigenous and natural subjects in Australian museums.

CREDITS

page iii
Pintupi men drinking from a lake
near Lappi Lappi rock-hole,
Central Australia, 1957
Photograph by D.F. Thomson/Courtesy of
Mrs D.M. Thomson and Museum Victoria.

page iv (and front cover)
Pitani Tjampitjinpa standing next to
Donald Thomson's expedition truck,
Central Australia, 1957
Photograph by D.F. Thomson/Courtesy of
Mrs D.M. Thomson and Museum Victoria.

page vi
*Early days living at the mission at Haasts
Bluff where everyone was happy* 2004
Wentja Napaltjarri 2
acrylic on canvas
Reproduced courtesy of the National
Aboriginal Cultural Institute, Tandanya

page 1
Tjampirrpunkungku 1996
Katarra Nampitjinpa
Gantner Myer Collection, Museum Victoria.

Satellite photograph of Lake Mackay region,
Central Australia
Courtesy Resource Imaging Australia.

page 3
Mitjili Napanangka (standing),
Mamunya Lyle Tjakamarra (child) and two
unidentified women drinking from the Lappi
Lappi rock-hole, Central Australia, 1957
Photograph by D.F. Thomson/Courtesy of
Mrs D.M. Thomson and Museum Victoria.

page 5
Pintupi family camped in Central Australia, 1957
Photograph by D. F. Thomson, 1957/Courtesy
of Mrs D.M. Thomson and Museum Victoria.

A Pintupi man taking a bath with
Bill Hosmer, a member of the 1957
Donald Thomson expedition to
Central Australia
Photograph by D.F. Thomson/Courtesy of
Mrs D.M. Thomson and Museum Victoria.

Patuta Arthur Tjapanangka, Lake Mackay
region, Central Australia, 1957
Photograph by D.F. Thomson/Courtesy of
Mrs D.M. Thomson and Museum Victoria.

page 6
Unidentified figures in the Kintore Ranges
region, Central Australia, 1957
Photograph by D.F. Thomson/Courtesy of
Mrs D.M. Thomson and Museum Victoria.

Men recently arrived at Hermannsburg,
viewing Rex Battarbee's watercolour
paintings, circa 1945
Photograph by Rex Battarbee.
Reproduced courtesy of Gayle Quarmby.
Sourced from *A Straight-out Man:
F.W. Albrecht and Central Australian
Aborigines* by Barbara Henson.

Teltelkna 1945, Rex Battarbee
Private Collection.
Reproduced courtesy of Gayle Quarmby.

page 7
The missionary Ernest Kramer and family,
reproduced from a self-published booklet
on his work, circa 1930
Courtesy South Australian State Library.

Pastor Albrecht sitting with a group
near Haasts Bluff, circa 1940
Photograph by Rex Battarbee.
Reproduced courtesy of Gayle Quarmby.
Sourced from *A Straight-out Man:
F.W. Albrecht and Central Australian
Aborigines* by Barbara Henson.

page 8
Man drawing on paper, Mt Liebig, 1932
Photograph courtesy of the Museum
Board of the South Australian Museum.

Crayon drawing by Mintun Mintun.
Mt Liebig, 1932
Photograph by Mick Bradley.
Courtesy of the Museum Board of the
South Australian Museum.

Luritji boy 1934, Arthur Murch
Arthur Murch. Australia 1902–1989;
worked in Europe 1936–40
coloured pastel on light brown paper.
25.4 x 20.2cm irreg. (image).
Purchased, 1934. National Gallery
of Victoria, Melbourne.
Reproduced courtesy of Ms Ria Murch.

Drawing by H.K. Fry of Wanatjakurrpa
or 'Maurice' at Mt Liebig, Central
Australia, 1932
Photograph by H.M. Hale.
Courtesy of the Museum Board of the
South Australian Museum.

page 9
Extract from a story by Max Lampshed
about the scientific expedition to
Mt Liebig and published in the
Adelaide newspaper *The News*, 1932
Courtesy of the Museum Board of the
South Australian Museum.

page 10
A group of Pintupi walking in from the west
to meet the University of Adelaide Expedition
at Mt Liebig, Central Australia, 1932
Photograph by H.M. Hale.
Courtesy of the Museum Board of the
South Australian Museum.

page 11
Cameraman E.O. Stocker, takes film footage
at Mt Liebig, Central Australia, 1932
Photograph by H.M. Hale.
Courtesy of the Museum Board of the
South Australian Museum.

page 12
Men listening to a shortwave wireless
at Mt Liebig, Central Australia, 1932
Photograph by H.M. Hale.
Courtesy of the Museum Board of the
South Australian Museum.

page 13 (and front cover)
Photo identification card for
Pintupi woman, Waripanda
Produced by Norman Tindale,
Mt Liebig, Central Australia, 1932.
Photograph by Mick Bradley.
Courtesy of the Museum Board of the
South Australian Museum.

Genealogical information card for Waripanda
Compiled by Norman Tindale,
Mt Liebig, Central Australia, 1932.
Photograph by Mick Bradley.
Courtesy of the Museum Board of the
South Australian Museum.

page 14
Plaster life-cast of Waripanda
Photograph by Mick Bradley.
Courtesy of the Museum Board of the
South Australian Museum. A20383

Carrying dish collected from Waripanda
Photograph by Mick Bradley.
Courtesy of the Museum Board of the
South Australian Museum. A17699

Pubic apron collected from Waripanda
Photograph by Mick Bradley.
Courtesy of the Museum Board of the
South Australian Museum. A17630

Fibre rope collected from Waripanda
Photograph by Mick Bradley.
Courtesy of the Museum Board of the
South Australian Museum. A17678

page 15
Reproduction of a cartoon from the
booklet, *Rocket Range Threatens Australia*,
published by the Australian Communist
Party in c1947.
Courtesy of the State Library of
South Australia.

Static firing of a Blue Streak rocket at
Woomera. In the only mishap, a Blue
Streak broke up, scattering debris across
the south-east of the Central Aboriginal
Reserve. No one was injured as a result
Photograph courtesy of the
Australian Department of Defence.

page 16
Pintupi men examining a spearthrower
with carvings of various waterhole sites
Photograph by D.F. Thomson/Courtesy of
Mrs D.M. Thomson and Museum Victoria.

A newspaper pictorial supplement about
Donald Thomson's 1957 expedition to
Central Australia published in *The Age*,
13 and 20 November, 1957
Courtesy of *The Age*.

Donald Thomson discusses
iconographic decorations on a
spearthrower with a group of
Pintupi men
Courtesy of Mrs D.M. Thomson and
Museum Victoria

page 18
The Gunbarrel Highway across
Central Australia was constructed by
Len Beadell in the early 1960s.
This road still serves as the main
thoroughfare for most Western Desert
Aboriginal communities
Photograph by Len Beadell.
Reproduced courtesy of Anne Beadell.

page 19
A reconnaissance party of the
Weapons Research Establishment
and Pintupi men in the southern
Central Aboriginal Reserve, 1950
Photograph courtesy of the
Australian Department of Defence.

page 20
Stockmen near Haasts Bluff,
Central Australia, circa 1955
Courtesy of the State Library of
Victoria Collection.

page 21 and 22
Stills taken from the film *Pintupi*, an ABC documentary made by Frank Few in 1964 while on patrol in the Western Desert with Jeremy Long. The sequence of stills depicts the patrol meeting members of Anatjarri Tjampitjinpa's family, some of whom had never met Europeans before. Photography by Frank Few. Courtesy of the Australian Broadcasting Corporation.

page 23
Spinifex resin
Woomera (detail)
Woomera
Boomerang
Bark twine footwear
Carrying dish
Bark twine bundle
Photographs by Ben Healley.
Collection Museum Victoria.
Reproduced courtesy of Mrs D.M.Thomson.

page 24
Carrying dish
Photograph by Ben Healley.
Collection Museum Victoria.
Reproduced courtesy of Mrs D.M.Thomson.

page 25
John Tjakamarra near Walungurru, Kintore Range, 1974

Fred Tjungurrayi Ward, Kiwirrkura, 1990

page 26
Elwyn Tjampitjimpa Yapa, Kiwirrkura, 1990

Charlie Tjakamarra Ward, Kiwirrkura, 1990

Photographs by Jon Rhodes and were included in the 'After 200 Years Project'. Courtesy of Jon Rhodes, the Kiwirrkura Council and the Australian Institute for Aboriginal and Torres Strait Islander Studies, Canberra.

page 27
Photograph taken in 2004, of Thomas, Warlimpirrnga, Yalti and Yukulti who walked out of the bush in 1984.
Reproduced courtesy of photographer Kylie Melinda Smith.

Front page of the Melbourne newspaper, *The Herald*, 24 October, 1984
Photograph by Peter Ward.
Courtesy of the *Herald & Weekly Times*.

page 28
Two boys Dreaming at Marruwa 1987
Warlimpirrnga Tjapaltjarri
Pintupi born circa 1960
synthetic polymer on canvas
121.3 x 75.9cm.
Gift of Ron and Nellie Castan, 1989.
National Gallery of Victoria, Melbourne
Copyright the artist licensed by
Aboriginal Artists Agency 2006.

page 29
Possessions left near Ilpili, Ehrenberg Range, by Pintupi people who walked into Haasts Bluff, circa October, 1956
Photograph by and courtesy of Jeremy Long.

page 32
Kulayi Tjakamarra and two boys emerge from the scrub
Photograph by and courtesy of Jeremy Long.

Kulayi Tjakamarra and the two boys climb the sandridge to meet the Welfare Branch patrol, near Militjipi Well, west of Mt Farewell, 12 June, 1957
Photograph by and courtesy of Jeremy Long.

The patrol with women, men and children at Yura-lari-panta claypan, west of Lake Mackay, 29 June, 1957
Photograph by and courtesy of Jeremy Long.

Dr John Hargrave conducting a medical examination at the claypan,
29 June, 1957
Photograph by and courtesy of Jeremy Long.

page 34
Fred West Tjakamarra, his young brother, and George Yapayapa Tjangala just after they walked into the camp at Tawultjarra, Dovers Hills, 12 June, 1962
Photograph by and courtesy of Jeremy Long.

Timmy Payungka Tjapangarti cooking kangaroo. Yarrannga Well,
2 November, 1957
Photograph by and courtesy of Jeremy Long.

Natiki and Tjalyurri Tjapaltjarri with George Tjampu Tjapaltjarri and Pawun Tjungarrayi (obscured), near Dovers Hills, Western Australia, 12 June 1962
Photograph by and courtesy of Jeremy Long.

Timmy Payungka Tjapangarti leaves to search for his family east of Lake Macdonald, 14 July, 1958
Photograph by and courtesy of Jeremy Long.

page 36
John Tjakamarra approaching the patrol party in sandridge country south of Mt Webb, 8 July, 1962
Photograph by and courtesy of Jeremy Long.

John Tjakamarra, his child and wife Minyantu, 8 July, 1962
Photograph by and courtesy of Jeremy Long.

page 37
First Contact 2005
Wintjiya Napaltjarri Morgan, Kathleen Whisky Nungarrayi, Colleen Whisky Nampitjinpa, Ngoia Napaltjarri Pollard and Ulkalara Napaltjarri.
acrylic on canvas.
On loan from Watiyawanu Arts of Amunturrngu Inc. and reproduced courtesy of the National Aboriginal Cultural Institute, Tandanya.

page 39
Freddy West as a young man living in the Western Desert, 1962
Photograph by and courtesy of Jeremy Long, 1962.

Freddy West in the early 1990s
Photograph by Christopher Hodges.
Courtesy of Christopher Hodges and Utopia Art, Sydney

page 40 (and back cover)
Mantua Nangala, age five, 1964
Photograph by and courtesy of Douglas Lockwood.

Mantua Nangala, 2004
Photograph by and courtesy of Philip Batty.

page 41 (and back cover)
Photo identification card for
Mick Namarari, age nine, 1932
Photograph by Norman Tindale,
Mt Liebig, 1932. Courtesy of the Museum Board of the South Australian Museum.

Mick Namarari, 1991
Photograph by Grenville Turner.
Courtesy of The Right Image Pty Ltd.

page 42 (and back cover)
Photo identification card for Johnny Warangula Tjupurrula, age ten, 1932
Photograph by Norman Tindale, 1932.
Courtesy of the Museum Board of the South Australian Museum.

Johnny Warangula Tjupurrula, 1979
Photograph by and courtesy of Philip Batty.

page 43 (and front cover)
Mitjili Napanangka carrying her son, Mamunya Lyle Tjakamarra, 1957
Photograph by D.F. Thomson/Courtesy of Mrs D.M. Thomson and Museum Victoria.

Mitjili Napanangka, 1999
Photograph by Paul Sweeney.
Courtesy of Philip Batty.

page 44
Benny Tjapaljarri, 1996
Photograph by and courtesy of Philip Batty.

page 45
Untitled 1975–1976, Uta Uta Tjangala
synthetic polymer paint on
linen canvas, 230.0x380.0cm.
Purchased with funds provided by the Art Gallery Society of New South Wales 2004.
Collection: Art Gallery of New South Wales.
Copyright the artist licensed by Aboriginal Artists Agency 2006.

page 47
Uta Uta Tjangala
Photograph by and courtesy of
John Corker.

page 48
Old Man's Dreaming
Uta Uta Tjangala
Australia, C1920–1990
1983, Muyinnga. Northern Territory
synthetic polymer paint on canvas
242.0 x 362.0 cm
South Australian Government Grant 1984
Art Gallery of South Australia, Adelaide.
Copyright the artist licensed by Aboriginal Artists Agency 2006.

page 50
Tingari Story 1986, Willy Tjungurrayi
synthetic polymer paint on
linen canvas, 242.5x362.5x4cm stretcher.
Mollie Gowing Acquisition Fund for Contemporary Aboriginal Art 1993.
Collection: Art Gallery of New South Wales.
Copyright the artist licensed by Aboriginal Artists Agency 2006.

ACKNOWLEDGMENTS

For assistance in identifying people in the Thomson photographs I thank Peter Bartlett, Mitjili Gibson Napanangka, Cindy Gibbson Nagamarra, Bobby West Tjuparrula, Jeremy Long and Chris Armstrong.

For assistance in coordinating the commissioning of the Mt Liebig paintings, Glenis Wilkins. Thanks also to the artists Wintjiya Napaltjarri Morgan, Kathleen Whisky Nungarrayi, Colleen Whisky Nampitjinpa, Ngoia Napaltjarri Pollard and Ulkalara Napaltjarri.

For assistance in conducting research at the South Australian Musem, thanks to Philip Jones, Lea Lea Gardam, Philip Manning and Asher Faulkner.

A big thank you to the Museum Victoria team who helped put the exhibition and book together Alison Bartlett, Sanna Röppänen, Ingrid Unger, Michael Pennell, Melanie Raymond, Patty Brown, Mike Green, Melaine Raberts, Caine Muir, Rosemary Wrench, John Augier, Caroline Carter, Helen Privett, David Jay and Yolande Kerridge

For assistance in lending artworks, thanks to Judith Ryan and Maria Zagala National Gallery of Victoria; Rebecca Andrews, Art Gallery of South Australia and Hetti Perkins, Art Gallery of New South Wales. My thanks also to Mrs. Dorita Thomson and Julia Murray. Finally, a special thanks to the staff at the National Aboriginal Cultural Institute, Tandanya.

Philip Batty,
Exhibition Curator

Through the process of collaboration between the National Aboriginal Cultural Institute, Tandanya and Museum Victoria in producing this book and the exhibition, a productive and dynamic relationship has developed and the staff at Tandanya have benefited greatly. The Museum of Victoria staff, particularly Philip Batty, Curator, and Alison Bartlett, Exhibition Producer, have been extremely generous in their commitment, support and guidance of this extensive project.

I also acknowledge the commitment and dedication of Tandanya staff who have assisted in various ways to bring this exhibition to fruition. I particularly would like to thank Michael Diorio, former Tandanya Education Manager, for his dedicated work on this exhibition from 2001–2003. Equally the contributions of Rosie Potter, Mae Adams and Sandra Conte, Tandanya's successive Curator/ Visual Arts Managers, who have worked tirelessly to ensure the vision and integrity of the exhibition reached its full potential. In the same way I would like to thank Chantal Tremaine Henley, Tandanya Curatorial Assistant for 'holding the fort' at critical times during this project.

A big thank you to all the institutions and private collectors who have generously allowed us to access their collections and facilitated subsequent loans; particularly the Art Gallery of New South Wales, Art Gallery of South Australia, National Gallery of Victoria, Museum Victoria and the South Australian Museum.

Franchesca Cubillo,
Artistic & Cultural Director
National Aboriginal Cultural Institute, Tandanya

We gratefully acknowledge that this project has been assisted by the Australian Government through the Australia Council, its arts funding and advisory body.

We gratefully acknowledge that this project is supported by Visions of Australia, an Australian Government program supporting touring exhibitions by providing funding assistance for the development and touring of cultural material across Australia.

Presented by the Adelaide Bank Festival of Arts.